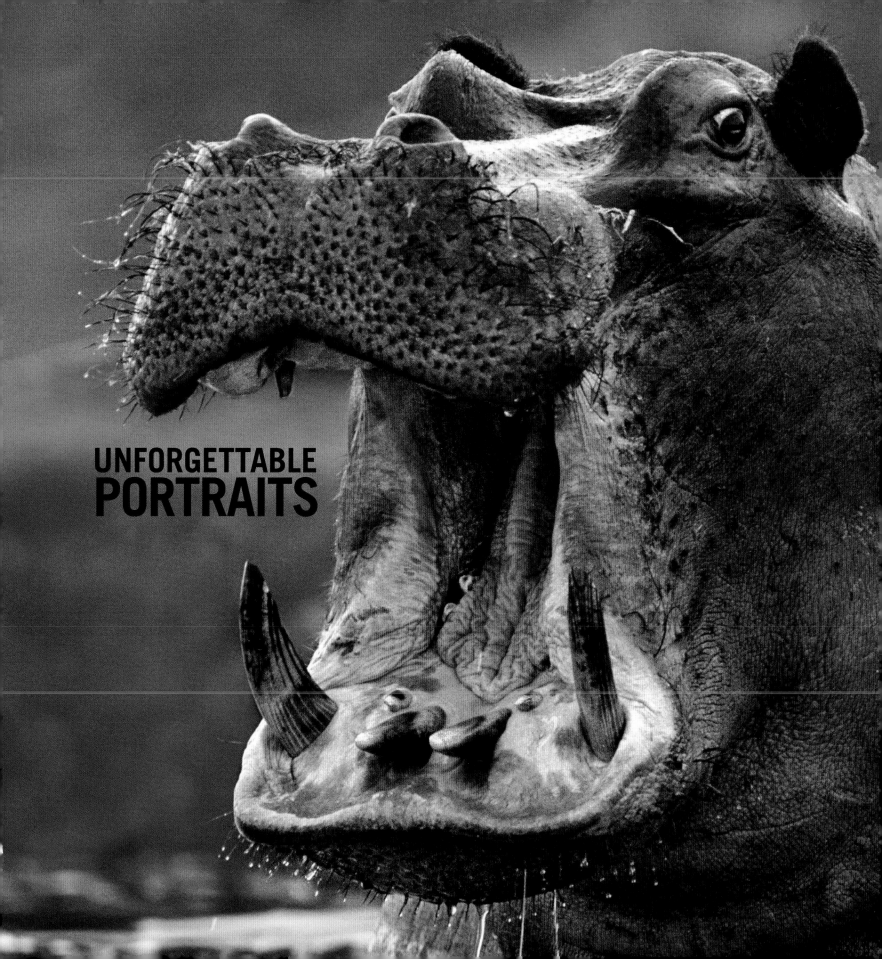

UNFORGETTABLE
PORTRAITS

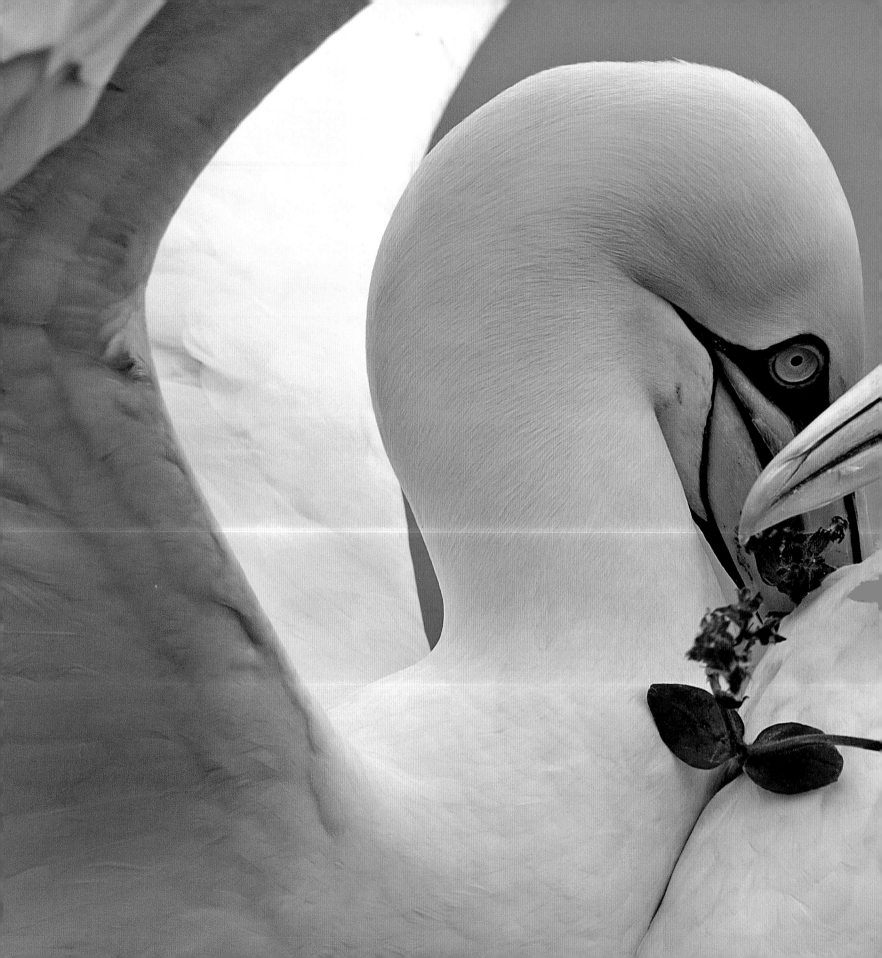

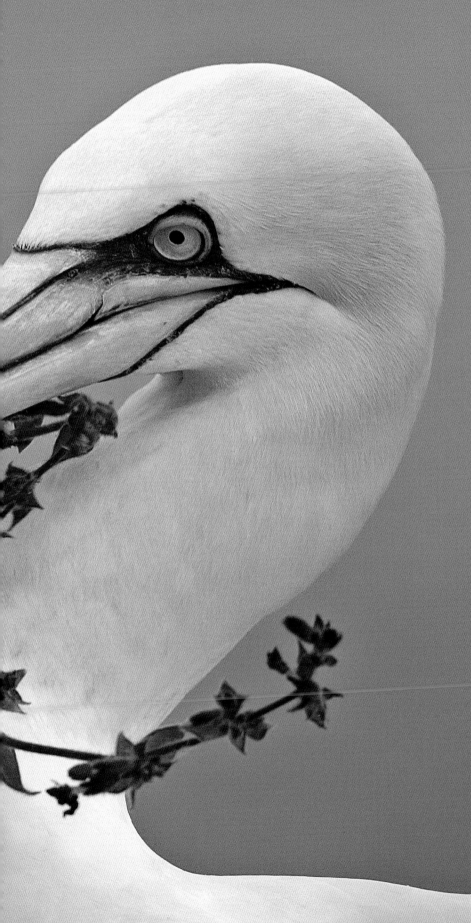

WILDLIFE PHOTOGRAPHER OF THE YEAR
UNFORGETTABLE
PORTRAITS

Rosamund Kidman Cox

FIREFLY BOOKS

CAPTURING
THE CHARACTER

The unforgettable portraits in this collection are all of wild subjects and have all featured in past Wildlife Photographer of the Year competitions. Some were winners of the top award, others were category winners, but all are memorable. They span more than 30 years, and include transparencies taken in the 1980s and 1990s, displaying the softness of film grain but also the artistry that makes them unforgettable.

A question raised by the title 'Portraits' is whether a photograph of a truly wild animal, an animal that cannot be posed, can ever be a true portrait – an artful representation rather than just a reproduction of a moment. But, of course, many of the most memorable portrait photographs of people are not posed; rather, they are moments chosen specifically because they reveal essential elements of a personality. And since the nature of a photograph can only ever be the capture of a moment, it is the knowledge of the subjects – where and how they choose to live, what they do, their routines and their personalities – that leads to and informs the choice of a moment. And so it is with wild creatures.

In the very early days of photography, images of wild animals were essentially trophy shots, without any understanding of or feeling for the animals. Exposure times were counted in seconds if not minutes, and so the first images were limited to subjects that weren't going to move, which included stuffed animals arranged in the manner of painted portraits. But with the development of photographic equipment, together with a growing understanding of the nature of other living creatures, photography moved away from capture and recording and towards artistic, truthful and meaningful portrayals.

Lighting has always been a crucial element of portraiture, both for freezing movement but also for actual illumination, most particularly for marine subjects, though it meant underwater photography had to wait for the development of sophisticated strobes before most subjects could be properly portrayed. Also crucial has always been the use of a backdrop, whether a single colour or tone, to focus attention on the subject or as context, literally setting the scene for a character.

Turn the pages of this book and you will find every portrait style. The classic canvas sets the subject against a plain backdrop, perhaps a studio-like curtain of black, a muted palette of snow or sky or a flat colour for a classic head-and-shoulders portrait. But you will also find angles and crops that create different ways of seeing an animal or plant (and, yes, plants can have character). And then there are the stories. Using a scenic backdrop, whether as a diorama or a composition that encapsulates an environment, also adds another dimension to our understanding of a character. Camera-trap images composed through choice use of lighting and setting can tell a story that is impossible to create otherwise. But the pictures we remember most are those that forge an intimate connection, bringing us closer to the subject so we gain respect if not empathy and share in the photographer's passion for the character and extraordinary nature of another living being.

Opposite: Study of a trophy hunter, Dallas, Texas.
By David Chancellor.

Previous page: Gannets paired for life, Bempton Cliffs, Yorkshire.
By Steve Race.

First page: Hippopotamus threat face, Linyanti Swamps, Botswana.
By Frans Lanting.

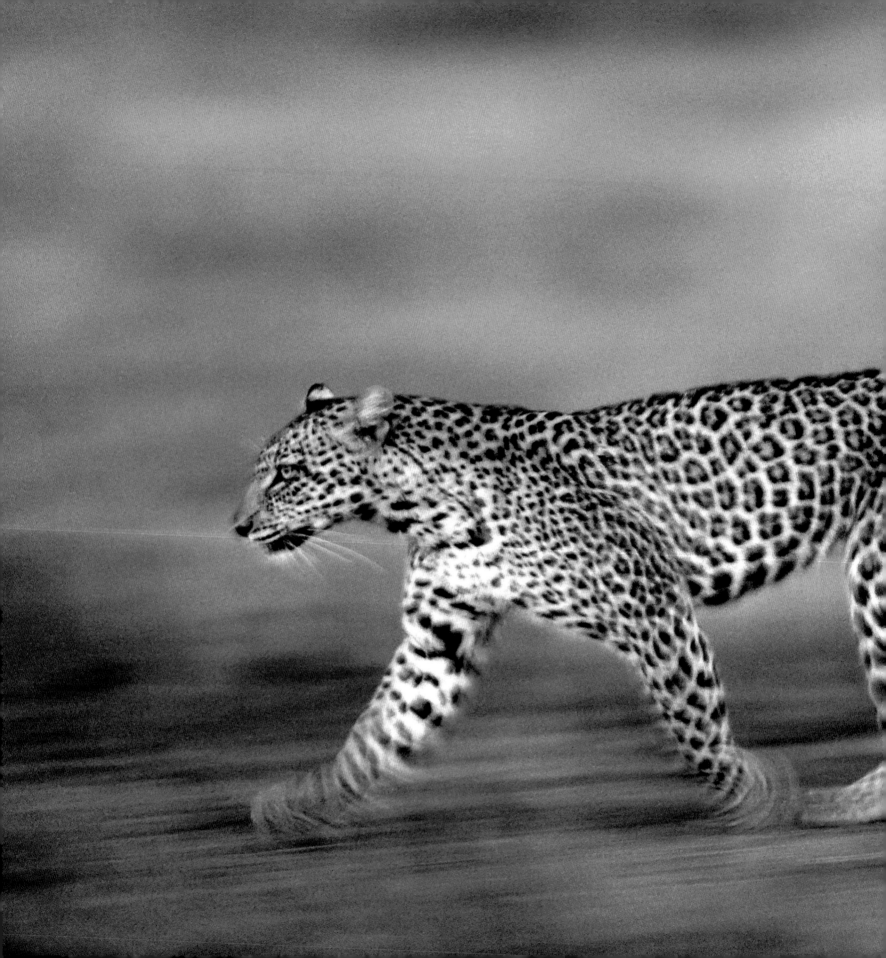

THE HUNTER

Konrad Wothe

Leopards are among the most popular portrait
subjects for photographers. But since leopards
normally sleep during the day, most portraits show
them reclining, usually draped over a branch. Rarely
does a portrait reveal the fluid grace of a leopard
in motion. To create such a shot required planning.
The photographer stayed for more than a week in
Tanzania's Serengeti National Park and got to know
the leopard's hunting area and where she was likely
to rest. He also knew that she would climb down from
her sleeping tree at dusk to begin hunting. This was in
the days of film, the 1990s, when a picture could be
taken after sundown only with the use of a low speed
and a wide aperture to capture the last of the light.
Working with rather than against the inevitable grain
that would result, the photographer enhanced the
sense of movement by panning the camera along with
the stride of the leopard, keeping the focus on her
eye. The result was a painterly representation and a
prize-winning picture that has stood the test of time.

RIVER MONSTER

Michel Loup

To encounter face to face a wild anaconda – and the largest species, the green anaconda – was the chance of a lifetime. So having spotted the 6-metre (20-foot) female slithering down the river bank, the photographer – who was already in the river, snorkelling for fish – slowly moved towards her. It was the end of the dry season in Brazil's Pantanal wetland and, swelled by rain, the river was exceptionally clear, allowing the photographer to shoot using natural light. At first, the snake moved to hide among the water plants, then when curiosity got the better of her, she approached to within a hand's distance of his mask, her tongue flicking in and out to pick up any scent that might identify this new animal. There is no authenticated account of an anaconda killing a human – indeed, they tend to avoid encounters – but they are opportunist hunters. A big one is capable of killing, swallowing and digesting an animal – usually a capybara or a caiman – up to half its own size. The attack is a swift bite using needle-sharp, curved teeth to hold the prey while the anaconda coils around the main body. It will then slowly, but with immense strength, constrict to suffocate the victim by forcing the air out of its lungs and, sometimes, holding it under water until it drowns. It then swallows the animal whole, elastic ligaments allowing its jaws to move apart so it can engulf it head first. In this instance, the female decided to retreat, to lie among the water plants with her head raised just slightly above the water so she could both see and breathe (her eyes and nostrils are suitably positioned on top), her green and patterned skin providing the perfect camouflage for an ambush hunter. This being the start of the rainy season, it was also the beginning of the mating season, and the likelihood was that a number of males – all very much smaller – would soon scent her and compete to mate, pushing at each other to access her cloaca, resulting in one of the most extraordinary of Pantanal sights – a writhing breeding ball of anaconda.

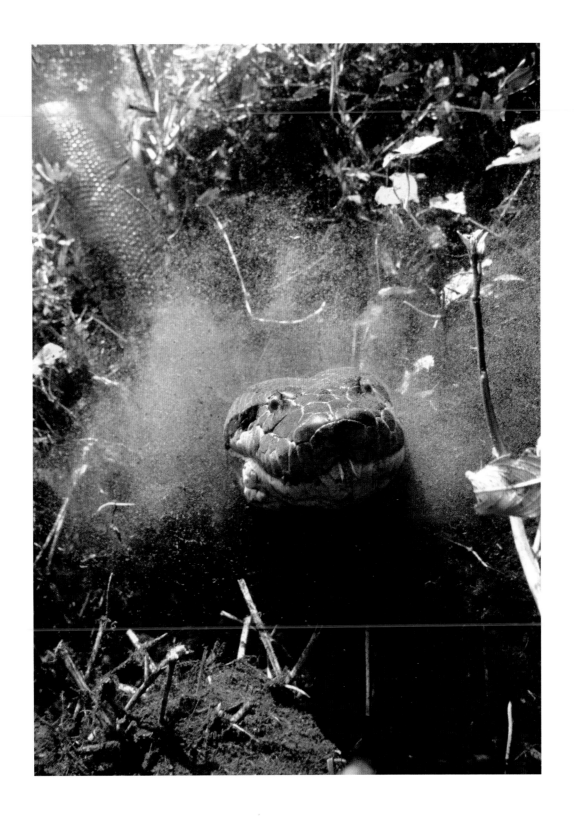

LITTLE WATCHER

Cyril Ruoso

The photographer couldn't have asked for a more
perfect pose or a more photogenic sitter. Though
it was a cold, overcast morning in China's Qinling
Mountains, with frost on the ground under the forest
canopy, the soft light was perfect for photography.
And for the young monkey, the fascination of the
bipedal primate and his tripod and lens on a facing
slope was irresistible. Having left the warmth of its
mother, it sat where it had the best view, perfectly
balanced, tucking in its feet and hands for warmth.
The youngster was the photographer's favourite in
the troop of Qinling golden snub-nosed monkeys he
was following. Ever playful, this monkey was bolder
than most, climbing up high, trapeze-swinging
from branches or teasing its playmates, and if it
felt the need of comfort, taking a hug from other
troop members, who are highly protective. Though
the monkeys occasionally come to the ground, they
mostly feed in the trees, on leaves, bark, buds and
lichen – so little ones need to learn to be agile. For
the smallest there is a risk of a swooping goshawk
or, more rarely, a golden eagle. But the real danger
for all races of snub-nosed monkeys is deforestation,
the spread of the human population and, in the past,
hunting. In the last millennium, golden snub-nosed
monkeys occurred in both lowland and upland areas
across eastern, central and southern China. But today,
fewer than 4,000 individuals remain, confined to a
series of nature reserves in southern Shaanxi province.

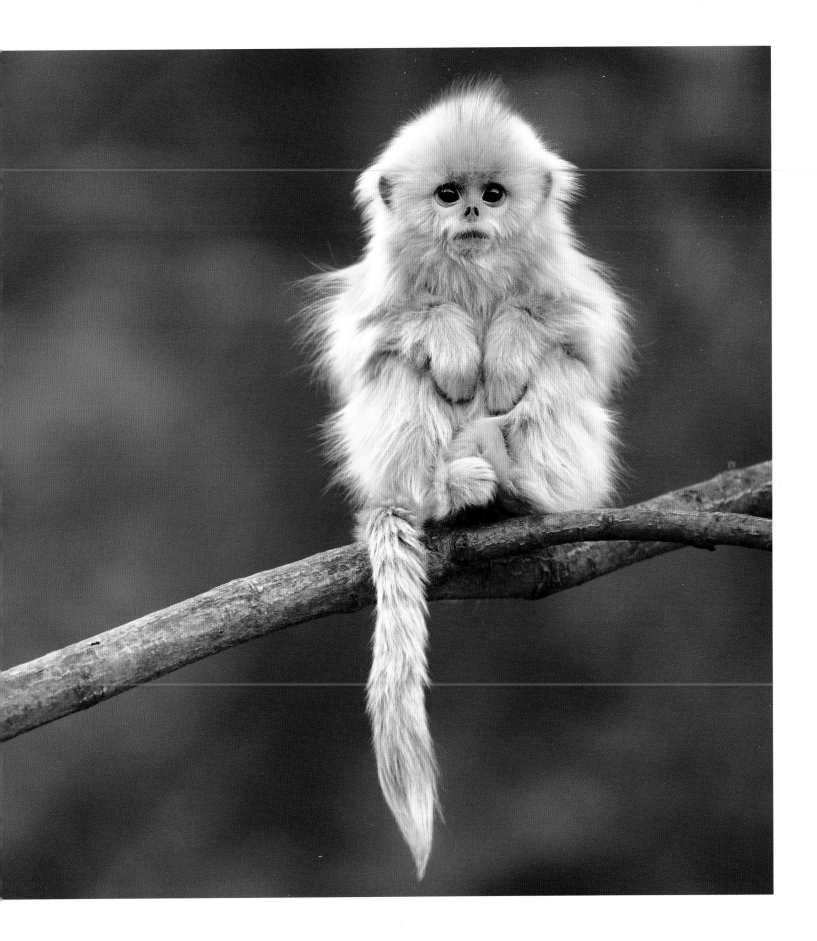

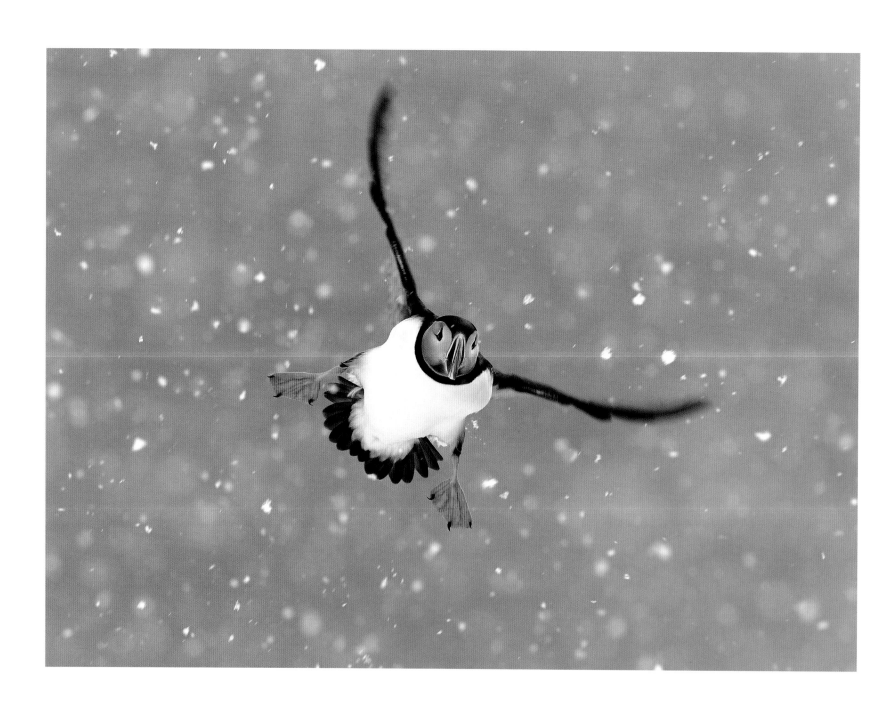

SNOW PUFFIN

Jan Vermeer

Flying in with the blizzard, an Atlantic puffin spreads its tail and feet as it prepares to land on a windy cliff-bank on Hornøya, an island off the northeastern tip of Norway. The bird is one of the first of a puffin flotilla to arrive. It is decked in full breeding dress, including a newly coloured-up bill, as it returns to the island after a winter at sea. In the Arctic Circle, puffins must get to their nesting sites as early as possible, from March onwards, to have the best chance of rearing chicks before the often abrupt end of summer – but not so early that the ground is still frozen. To have a chance of photographing a puffin flying in with the snow, the photographer also had to be there early, to await the arrivals and to catch the last snow flurries. His reward was the first ever shot taken of a puffin amid snow. Arriving puffins either reclaim their traditional burrows or, if new breeders, lay claim to one or dig one. If a burrow is blocked with a roof-fall or snow or ice, the puffin's beak becomes a shovel. If a fight breaks out over a burrow, beaks become weapons. Typically, puffins mate for life and nest in the same burrow year after year, defending it throughout the season. On Hornøya, a single egg is laid in May, the date dependent on the weather, and after a long incubation, the chick will hatch towards the end of June or even early July if breeding started late. In good years, the Barents Sea will provide plenty of fish such as capelin to feed to the chicks – one reason the island is a popular breeding spot for many species. There can be 80,000 seabirds, including more than 7,000 puffins. When fishing in the sea, puffins become 30-centimetre (foot-long) torpedoes and, if necessary, will range widely in search of fish. But should changing sea temperatures mean that the fish shoals move too far away, a whole colony of chicks can starve. So though an early bird gets the burrow, its success still depends on both the weather and, ultimately, the climate.

ARCTIC TREASURE

Sergey Gorshkov

Head-on, perfectly exposed and framed against snow, this is a portrait that is not only expressive but also tells a story. It is early June, and spring has come to Wrangel Island in the Arctic Circle north of Siberia – one of Russia's coldest, most remote wilderness reserves. The Arctic fox has stolen the egg from the nest of a lesser snow goose. Holding its treasure with gentle precision, it is trotting to a spot near its den, where it will bury the egg in the tundra – effectively a cold larder for hard times. With freezing temperatures returning in September, its winter survival may depend on what it can cache during the brief summer. Though its subsistence diet is lemmings, at the end of May the arrival of possibly more than 100,000 pairs of snow geese from North America brings the promise of both eggs and, for a very brief time, goslings. Plus there is always the chance of sick or dead geese. The number of eggs an Arctic fox can steal depends in part on how much snow-free ground has opened up and therefore how close together the nests are. When they are close, the nesting neighbours may help attack a thief. But when nests are widely spaced – as is more common now that climate change is causing an increasingly earlier snowmelt – the egg-snatch rate can be as high as 40 a day. And when the eggs hatch in early July, it may also be possible for a fox to grab a gosling – at a time when meat is most needed for its cubs. For all Wrangel Island Arctic foxes, their fortunes are dependent not just on lemming numbers but also on the epic migration of snow geese and the life-saving treasure they bring.

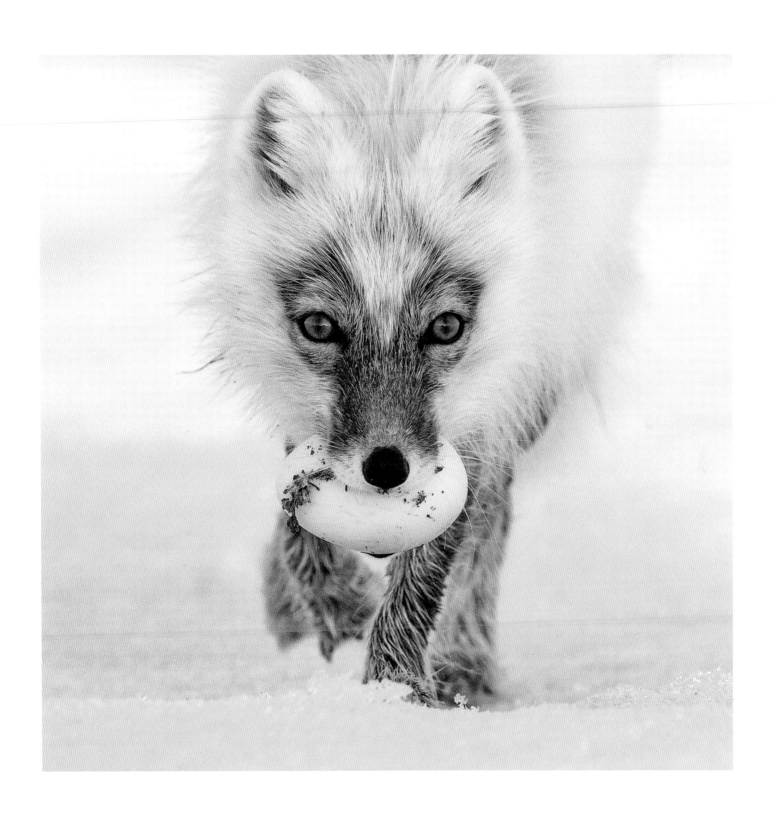

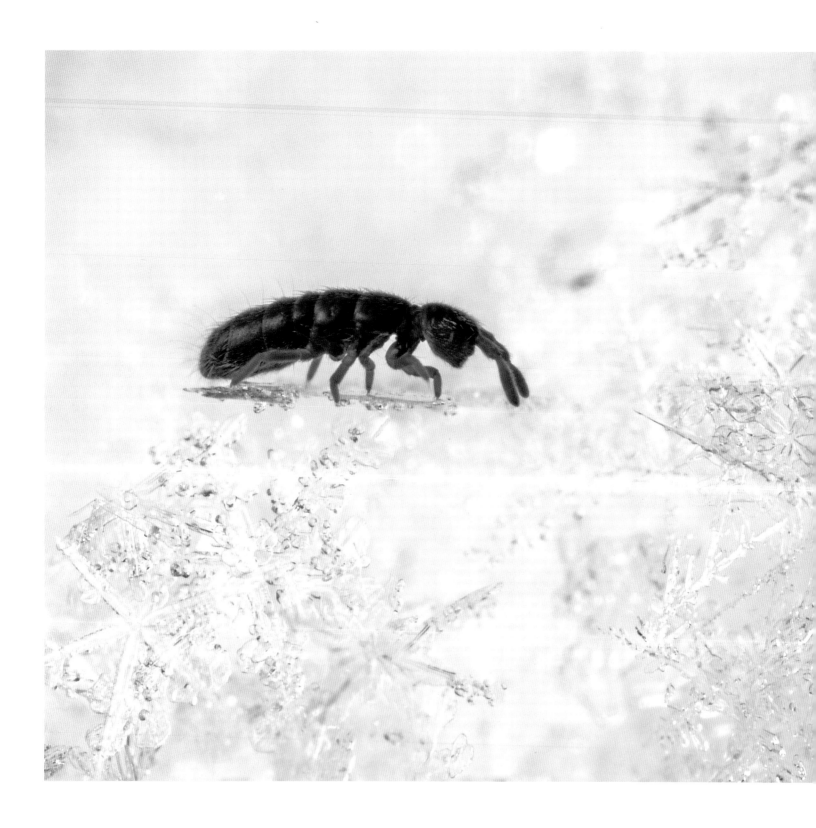

SPRINGTAIL ON A SNOWFLAKE

Urmas Tartes

A tiny furry springtail is portrayed delicately balanced on a snow-crystal. It is on its way up through the snowfield of crystals to forage for food particles on the surface. Also known as a snow flea, this type of springtail – which are as different from insects as spiders are – spends the winter in moist soil or leaf-litter. A covering of snow can act as an insulating blanket. But on a mild winter's day, when the temperature is warm enough for a snow flea to be active, it will spring up the snow-crystal scaffolding in search of organic morsels. It does so using its furcula, a special spring-loaded appendage folded under its abdomen. The furcula can also catapult it out of danger. But one danger this *Desoria* species probably can't spring out of is the web of a tiny spider that builds its trap in holes in the snow specifically to catch snow fleas. To get down to portrait level with this particular springtail, the photographer had to use five-times magnification and a 'soft box' to soften the flash that was needed to show the detail of hairs and eyes and give a sparkle to the snow flakes. Though we seldom notice springtails, they are one of the most abundant of all minuscule animals, found on all the continents – even Antarctica – and at all levels where there is suitable moist habitat, even in tree canopies. In fact, there are several orders of them – collectively, the Collembola. So wherever in the world you are, there will always be a springtail close by.

THE WATCHFUL PELICAN

Helmut Moik

With an almost human eye and pose, a head decked in finery, and a wing cloak of feathers masking its face, this remains an enigmatic portrait, even when given a name. Without a glimpse of the beak – among the world's biggest – it is hard to visualize this as a Dalmatian pelican, even though the waved silver-white feathers on its forehead and flamboyantly loose plumes on its head could belong to no other species. Photographed at dawn, on an island in Romania's Danube Delta, the bird is still in its sleeping position, with its head rotated 180 degrees and its beak resting on its back, buried in feathers. Notoriously shy, Dalmatian pelicans are easily disturbed, and so it was necessary for the photographer to enter his hide before sunrise and wait for dawn. The island and the marsh vegetation offer safety from predators, both for nesting – this population of pelicans migrates from the Mediterranean region to eastern Europe specifically to breed – and for sleeping. But like many birds, a pelican sleeps with one eye open and only half its brain resting, and then only in snatches, adjusting how much of its brain is asleep by how open its eye is. Its bill, with its huge pouch of skin, is a marvellous tool, not only for scooping up fish and holding a catch, but also for evaporation-cooling when it exposes and flutters the skin. But on cold nights, with such a large area for heat loss, a huge beak can be a handicap – the reason for burying it in the feathers of its backrest, as the pelican inhales air warmed by its own body heat. With that in mind, this image of a Dalmatian pelican could be said to be a most thought-provoking portrait of Europe's biggest fishing bird.

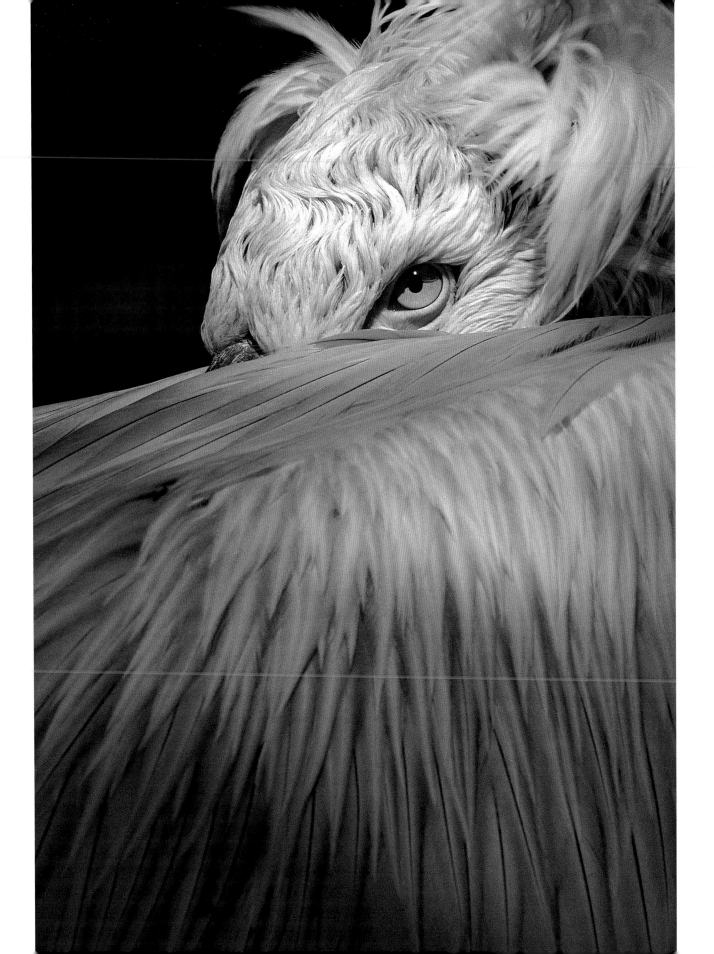

SPIRIT OF THE FOREST

Paul Nicklen

This is a bear that helped save a forest. It's a spirit bear, a white phase of the Kermode bear – a subspecies of the North American black bear. Spirit bears are found only in the temperate rainforest of British Columbia on Canada's west coast and especially on its offshore islands. This individual lives on Gribbell Island, where two thirds of the Kermode bears have inherited from each parent the recessive gene that leads to their white fur – a mutation of the same gene that also gives rise to red hair in humans. Photographed during the salmon migration, when salmon swim up the forest streams to spawn, the bear has retreated from a busy bear fishing area to feast in peace on its catch. Just a few years before, all of the old-growth area of the coastal rainforest was under threat of logging. But in 2006, after a 20-year struggle, and with the spirit bear as a symbol of what they had named the Great Bear Rainforest, conservationists finally achieved protection for much of the forest. That same year, the spirit bear was also made the official mammal of British Columbia. One theory for the survival of white bears, despite their conspicuousness, is the discovery that they are far more successful than their black relatives at fishing for salmon in daytime. Though not quite so prolific at night, they still catch more fish. But the undoubted reason is that the First Nations people living in the region have had a taboo against killing spirit bears – which has also kept them under the radar of hunters. In 2016, they banned trophy hunting of all bears on their territory. Though British Columbia still officially allows hunting of black bears, the spirit bears at least are safe.

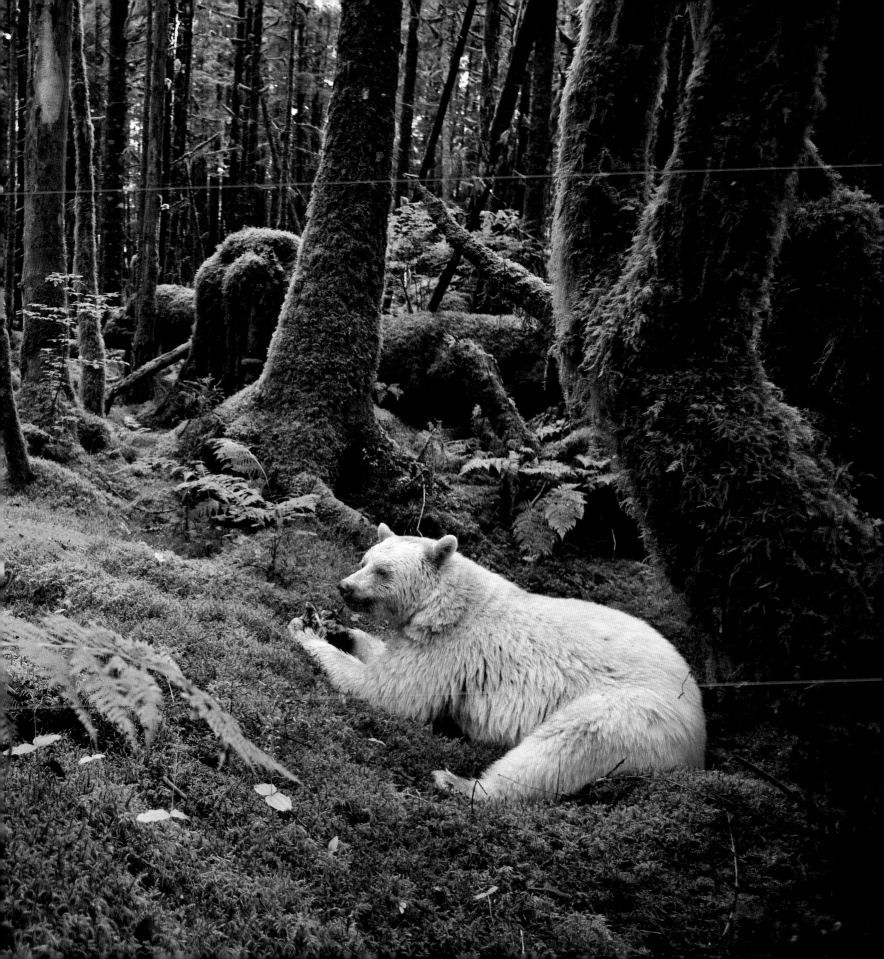

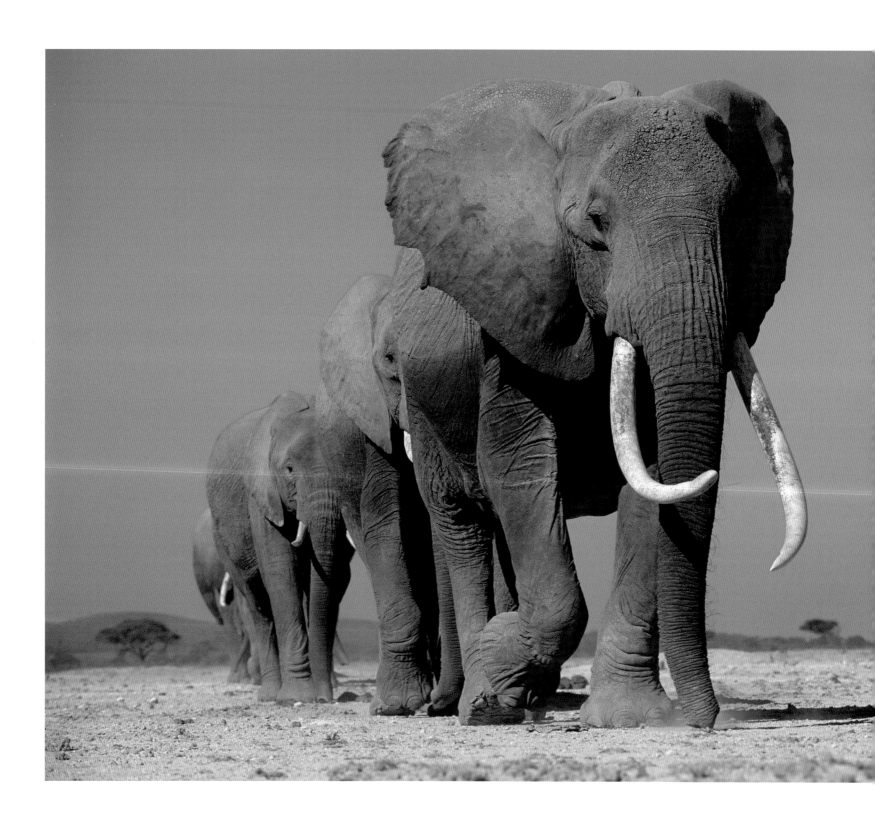

PROCESSION

Martyn Colbeck

This is both a family portrait and an immortalization of Jezebel – the most famous of African-elephant matriarchs, with her unmistakable long, curved tusks. She is shown leading her family group across a dry lake bed to a central swamp area in Kenya's Amboseli National Park, where they can feed and cool down in the heat of the afternoon. Knowing the likely route she would choose that day, the photographer waited for the elephants in his Land Rover, getting at ground level under it as soon as he saw them coming. Jezebel was familiar with the vehicle, and the procession passed close by, giving him the chance of an image that would convey the grandeur of these savannah giants. In 1993, shortly before the picture became a prize-winner, Jezebel died of natural causes, aged nearly 60. She had been monitored by the Amboseli Elephant Research Project since 1975, and during that period had successfully reared many young; and as a grandmother and grand aunt, she had helped many others born into the family group to survive the risky years of childhood. This image also shows two of Jezebel's sisters – Jill, with son Jethro, and Joyce bringing up the rear. When Jezebel died, Joyce – now the oldest and most experienced female – took over the leadership. She had acquired the wisdom to guide the family and was familiar not only with the region and where to find water and food in times of drought but also had the social knowledge that determined their interactions with the other clusters that form the extended Amboseli social system of more than 1,500 elephants. In 2009, both Joyce and Jill were killed by poachers, along with 30 per cent of the population, but since then, the Amboseli elephants have, thanks to major conservation efforts and the support of the local Maasai people, been spared the worst of the poaching epidemic. Today, Jezebel's descendants continue to thrive in the park.

GOOD FRIENDS
Edwin Giesbers

This is a portrait of male and female friends, relaxing after lunch – and also of character. The female (left) with the luxurious beard has furrowed her brows, giving a warning stare to someone not to violate her personal space. Both express attitude. Both also have official names – as had the macaque commemorated on the plaque behind – given to them (along with microchips) by their government carers and to all of the 200 or so Barbary macaques living on the rock of Gibraltar, a British protectorate in the Mediterranean. Gibraltar is the only place in Europe with free-living monkeys – five troops of them in the Gibraltar Nature Reserve. Their foraging is supplemented daily with fresh water, vegetables, fruit and seeds to manage their diet and to try to prevent them descending into town and stealing from tourists, who despite fines and warnings that macaques bite, still try to feed them. Gibraltar's macaques are related to both Moroccan and Algerian Barbary macaques, isolated and declining populations of which still exist mainly in the mountainous and forested regions of North Africa. Macaques were possibly first brought to Gibraltar as pets by the 'Moors' (people of North African Berber and Arab descent) who invaded Iberia. When most of Gibraltar's monkeys died in an epidemic in the 1900s, more macaques were brought in from North Africa. Barbary macaques live in mixed groups, and though males are bigger and more dominant, females still hold social power. Their young take on the social status of their mother – though depending on their personalities, that status can change. Males are also unusual among species of macaques in their interest in babies – indeed using them as social currency, even to diffuse conflicts. The theory is that, as females are promiscuous, the males have no idea which are their offspring – their genetic inheritance – and so it pays to be nice to all babies, and exhibiting a caring nature might also gain them mating privileges with the mothers.

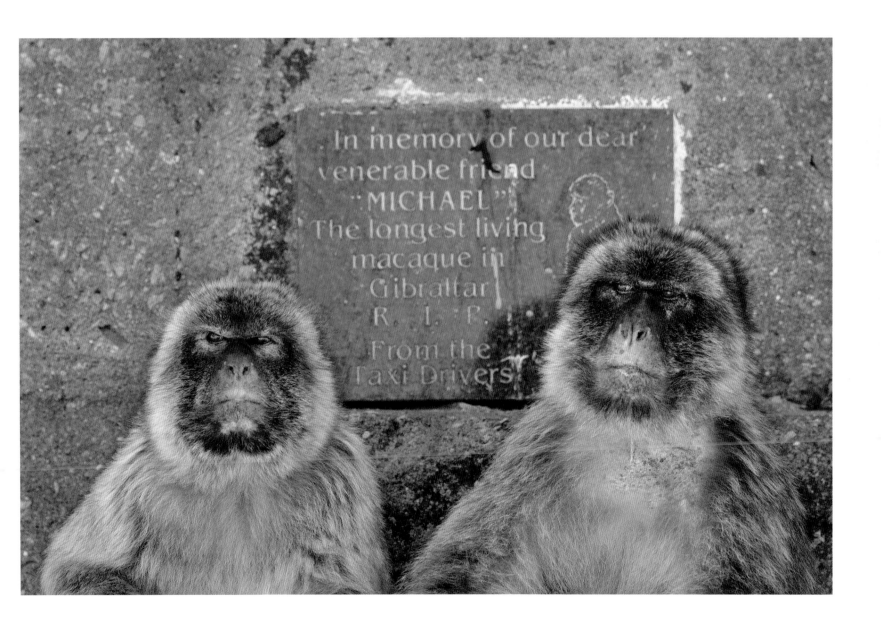

SWISH MOVER

Tim Laman

This portrait of a male twelve-wired bird of paradise shows him not at his most spectacularly beautiful, but at the pinnacle of his spectacular performance, posed at the top of his dance pole, with the object of his desire in the frame. With his back to the discerning female, he is mesmerizing her not just by the vivid yellow of his plumage but by swishing her face with the 12 wires that extend from the tips of his flank plumes. He has already attracted her to the pole with singing and a full-frontal display, exposing the metallic glint of his breast feathers and the startling emerald-green of the inside of his beak. Now he is at the intimate stage, which may or may not result in her allowing him to mate with her – a brief affair, after which their liaison will end. It all hinges on her judgement of his fitness. The pole itself is a tall dead tree in swamp forest on the island of New Guinea, which the male attends at dawn. So to get the shot, the photographer also had to be in position before dawn in a tree at the same height as the dance pole, then wait in a hide, and repeat the process for however long it would take for the finale of the display to materialize – seven days, as it happened. The extraordinary yellow of the male's feathers needs to be topped up by eating certain types of fruit to keep the feathers from fading to white. And the display itself needs to be practised and performed regularly if the male is to outperform his rivals, only possible because the forest provides plentiful, easily accessible fruit, leaving him with the time and energy to perfect his routine. That this female finally chose him to mate with means that her sons should inherit his winning looks and energetic persistence and that her daughters should have her good taste in fit males.

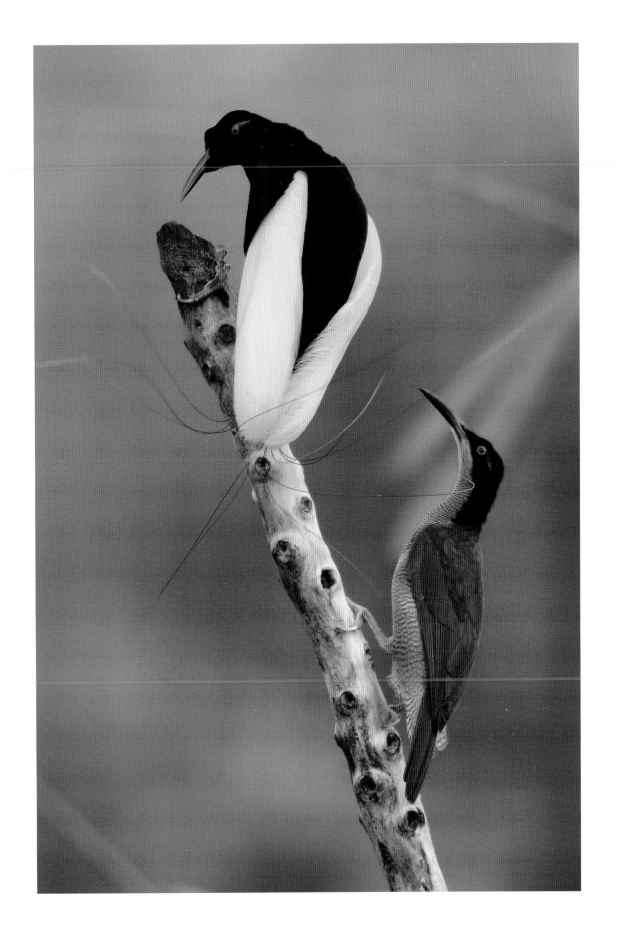

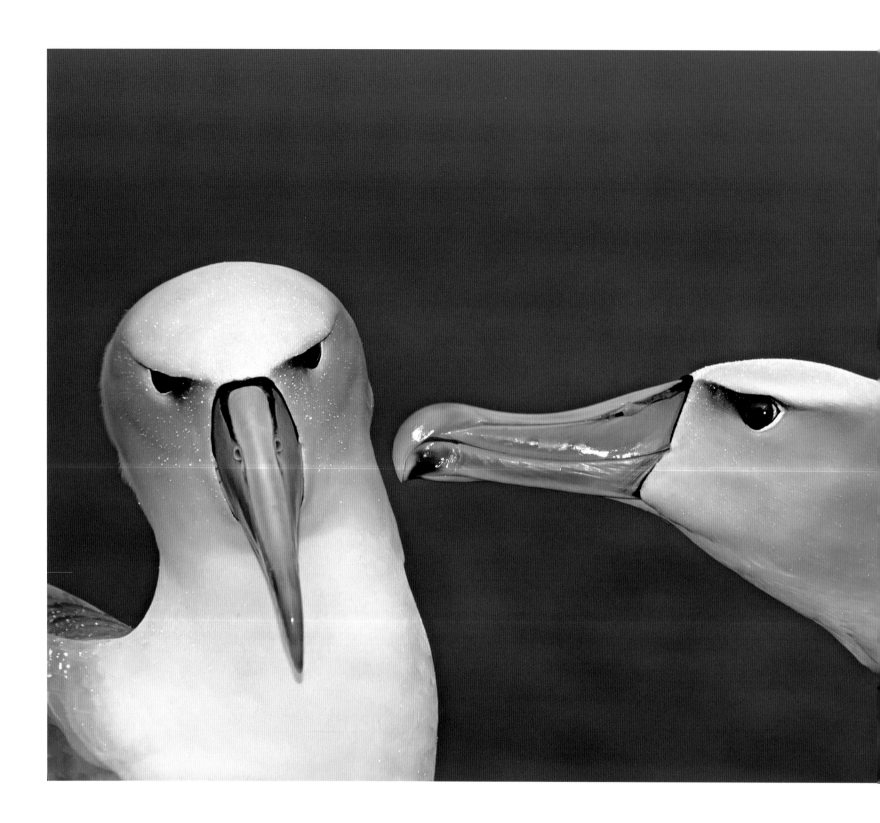

THE REUNION

Tui De Roy

Oblivious of the wind and rain, a pair of white-capped albatrosses engage in delicate courtship preening. It's a portrait of devotion, as these are life partners. The female (left) is perched on their mud-stack nest on a cliff-side on Auckland Island, in New Zealand's remote subAntarctic Auckland Island group. Both birds were born on the island. Most of their lives are spent far out at sea, but every couple of years they return to the island, to the same nest site, where they mate and eventually rear a single chick. They are not alone. The air is full of a cacophony of calls as pairs of white-capped albatrosses greet each other and engage in courtship rituals, involving much ceremonial bowing and curtsying. The island's cliff-sides host possibly 5,000 nesting pairs and, along with a much larger colony on neighbouring Disappointment Island, form the breeding stronghold for the majority of the world population of about 100,000 pairs. Though the remoteness of Auckland Island should make it a fortress, feral pigs – introduced in the past as food for whalers and sealers – eat any chicks they can reach. The pigs are to be culled, but the albatrosses' greatest threat will remain – being caught in the fishing gear of longliners and trawlers. Though they eat mainly fish, squid and other marine creatures, they also follow ships, feeding on offal. One estimate puts the numbers killed each year at 8,200. So in any one year on Auckland Island, there will be single birds at nests awaiting partners who will never return.

THE TREE HUGGERS

Frans Lanting

With almost staged symmetry, two strikingly handsome lemurs, known as Verreaux's sifakas, pose astride the forks of a tamarind tree in Madagascar's Berenty Reserve. Their long legs are designed for leaping vertically between tree limbs, but their powerful thigh muscles also enable them to use a unique bouncing bipedal gallop, arms held above their heads for balance, to cross between trees on the ground. Seated left is a male, his high-ranking status revealed by staining on his bib from the secretions of a gland on his throat, used to advertise sexually active status. He is most likely staying close to the female (right) because she is receptive – oestrus occurs only in January and February, so that babies are born in the dry season and weaned in the next wet season. A group of sifakas – up to 14 of them – may contain several males, though within their hierarchy, only one would normally have sexual rights. But females are dominant in sifaka society, and they are the ones who choose their mates. Together with the males, they use scent from their bottoms to demarcate the group's feeding area. Tamarinds are among their favourite food trees, providing leaves, fruits and flowers and even, as here, bark. Sifakas are choosy about what they eat and will travel in search of relatively high-quality, protein-rich food. Some of it may be selected for medicinal purposes. Females who are pregnant or with infants will select certain plants high in tannins, probably to stimulate milk production and possibly to kill parasites. Found only in southwestern Madagascar, these strange primates are now critically endangered. Their natural predators are hawks and Madagascar's carnivorous fossas, but their fate is linked to their fast-shrinking and fragmented forest habitat. Just recently, more than 30 lemurs, mostly males, out of a population of about 200 in the Berenty Reserve, died suddenly from a mystery disease, possibly exacerbated by stress from overcrowding or drought in a relatively small forest area, highlighting just how vulnerable this Malagasy primate is.

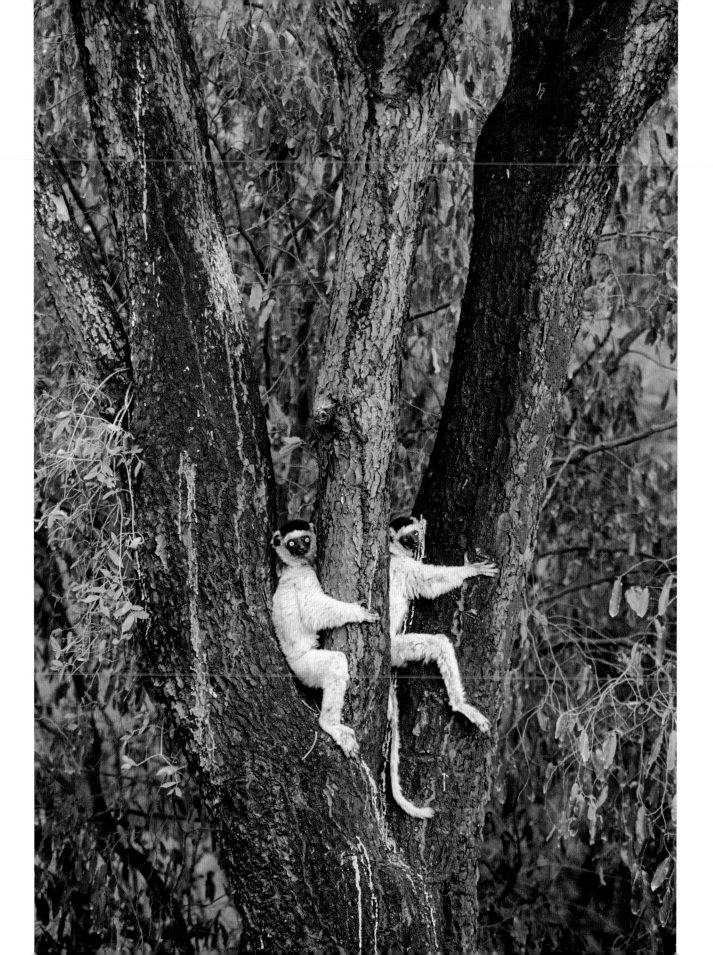

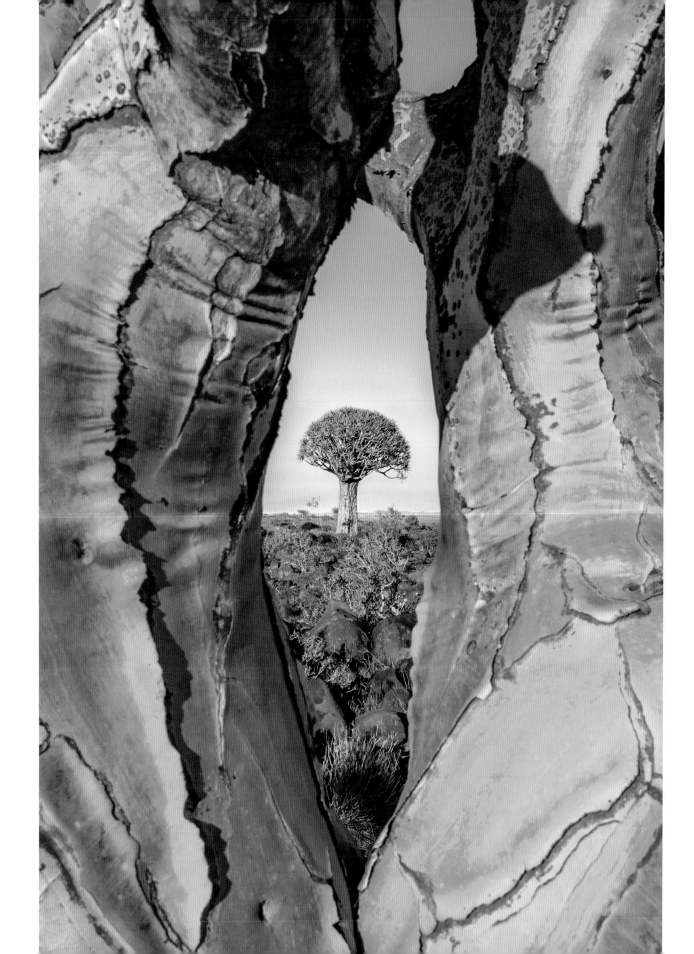

THE SUCCULENT TREE

Steffen Sailer

Using the fork of a possibly 200-year-old quiver tree as a frame for his portrait, the photographer focused on the mushroom-like profile of another quiver tree. This is not a true tree but a succulent – an aloe – the stems of which grow to tree-like proportions. The largest are up to 9 metres (nearly 30 feet) high – keeping the fleshy leaves well off the hot ground and away from browsers. Instead of wood, the stout stem and its bloated branches contain spongy pith, which can expand to take in more water when rain comes. The plant's smooth, corky bark splits to allow it to expand when drinking and to grow. To minimize water evaporation, there are few pores in the bark, and white powder on the branches reflects the sun. In times of drought, the quiver tree can both shed its succulent rosettes of spiky leaves and amputate its stumpy branches, sealing the wound. Towering over the rest of the vegetation, the quiver tree is the most visible and spectacular plant in the west-coast semi-desert of Namibia and South Africa. Indeed, it is Namibia's national plant. It also supplies a community of plants and animals, including birds and insects that feed on its sprays of flowers, and nesting birds such as sociable weavers that use the structure of its rosette of forked branches. Large mammals, from baboons to porcupines, use it as a source of moisture, and the San people used to fashion its light, bloated branches into quivers for their arrows. But though long-lived and drought-tolerant, this giant succulent is not invincible. It can die if there is a lengthy drought. Neither does it do well if there is a sudden and extreme increase in rain. Too much rain loosens the normally rock-hard soil and thus the grip of the quiver tree's shallow root plate. Also, the swollen, rigid plant is effectively top-heavy and susceptible in a storm to being wind-thrown. But this giant succulent has survived climate fluctuations in past millennia and might still survive whatever climate change brings in the future.

DESERT STRIKER

Thomas Dressler

Displayed in a characteristic S-shaped ambush posture, a Peringuey's adder wriggles down into the sand. A second longer, and only its eyes and the tip of its tail will be exposed. Discovered by the photographer, hunting on the slip-face of a dune in Namibia's Namib Desert, it has chosen to submerge itself for safety but also in anticipation of prey. With nostrils and eyes on top of its head – rather than at the side, as is usual in snakes – it can see and breathe while remaining hidden, and by bringing its tail close to its head, the tail tip can be wriggled like an emerging grub to bring a hunting lizard or a gecko within striking distance. Not all desert adders have black tail tips, but a buff-coloured one seems to work just as well as a lure. Depending on the season and temperature, the adder hunts on the surface by day as well as night, using a sidewinding technique that allows it to move surprisingly fast with, at any one moment, only part of its body in contact with the hot sand. Its prey is mainly diurnal sand lizards and nocturnal geckos, from which it obtains food and moisture. But like many animals and plants of the Namib, the snake's survival is partly dependent on the fog that most nights rolls from the sea and over the dunes. It also has a technique to catch the moisture, used especially in the hot summer. At dawn, as the fog rolls in, it flattens its now cold body against the sand, increasing the surface area for condensation. It then licks the droplets off its body, periodically raising its head to swallow the water – a drinking habit made possible only in the coastal strip of the Namib, where hot air from the desert meets cold air from the sea.

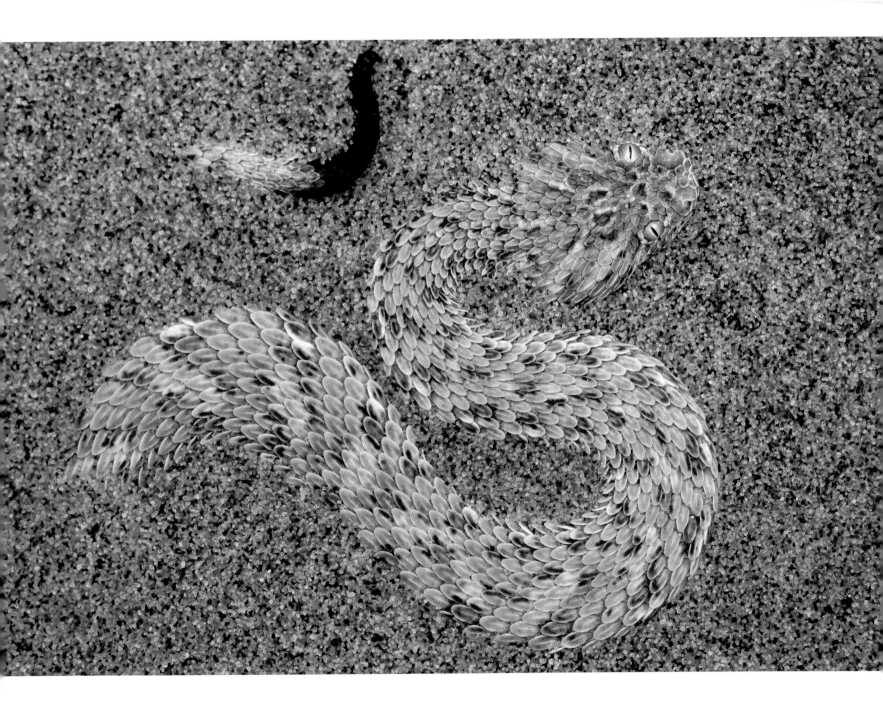

DESERT RELIC
Jen Guyton

This is a portrait in praise of a truly remarkable plant. Found only in the Namib Desert of Namibia and Angola, welwitschia bears no resemblance to other desert plants and hardly looks able to survive the extreme conditions of the Namib, where in some years it never rains. Yet individuals can live for more than 1,000 years, and the largest ones are reputed to be older than 1,500 years. An evolutionary relic, probably from the tropical Jurassic period, welwitschia evolved to cope with increasingly dry conditions, becoming relegated to Africa's southwest coast. The single species is placed in an order of its own, and though it is related to cone-bearing plants such as pines, it also has aspects of flowering plants. Individuals are either male or female. This one is female, with a crown of cones. Each flower on the cone extrudes a hair-like reproductive structure. This is topped by a stigma to receive pollen and produces a droplet of nectar as an enticement for insect visitors that just might deposit pollen from the cones of distant male plants. Unlike any other plant, welwitschia's corky trunk, like an inverted cone, grows outwards from the circumference. It produces just two leathery leaves that lie on the ground and grow continually, becoming torn into ribbons as they age and piling up in a tangled heap. They are the secret to its survival, enabling welwitschia to harvest moisture from the sea fog that rolls in at night – formed when the cold coastal current meets the hot desert air. The moisture condenses on the leaf straps and is channelled down to the roots. The leaves of this miraculous plant also provide a source of moisture for large herbivores such as desert rhinos and shelter for a community of small animals.

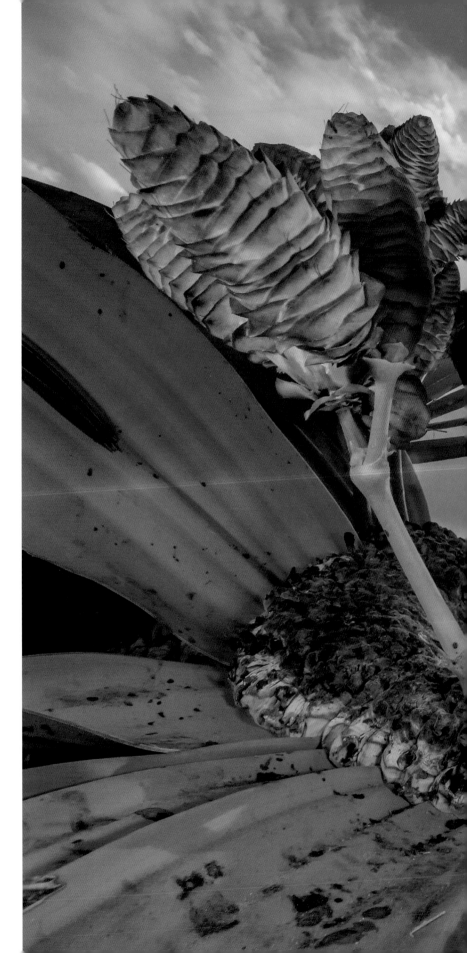

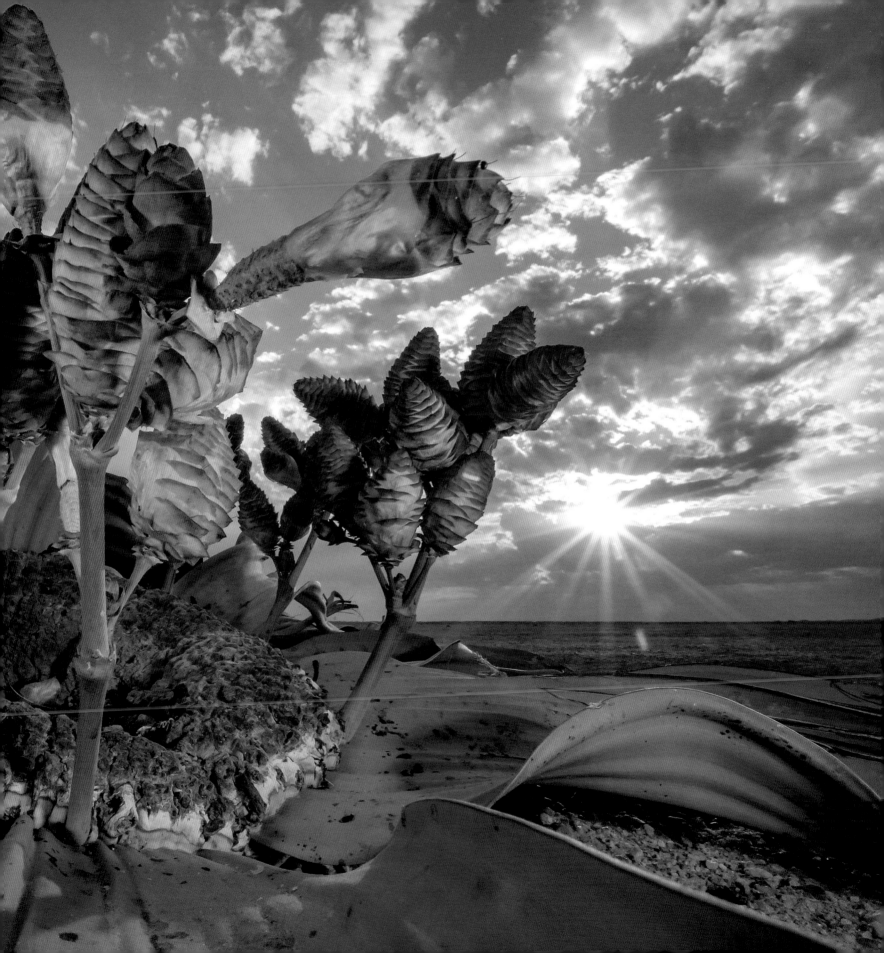

CALL OF THE RAVEN

Jarmo Manninen

Without doubt, a raven has personality. Wherever ravens exist in the northern hemisphere, there are myths and legends portraying the bird as having god-like powers – if not as an actual deity, then as a messenger of the gods and a supernatural mischief-maker. Its powers of communication and problem-solving, including its use of tools, place it among the most intelligent of social animals. Here, in early spring in Finland – courtship time – this male is portrayed in communication with his lifelong partner, as well as other ravens in the vicinity of the pair's breeding territory. His vocalizations include combinations of *kuorrk, kuarrk* and *kueek* along with noises that include clucks, pops, croaks and even drum rolls. Not only do ravens have a vast repertoire of sounds, they can also gesture by pointing and will wave objects around to get the attention of other ravens or invite play. Ravens have even been known to use loud, raucous calls to summon wolves to an animal carcass so they can feed on the remains once the wolves have torn the hide open. Here, a blizzard against a backdrop of fir trees highlights the glossy blue-black of the bird's throat hackles and body plumage, and a sprinkling of snow on its head picks out the raven's black eye, which might otherwise merge into the jet black of its feathers. The snow is also a reminder of the harsh conditions of far-northern locations, where food in winter is in short supply, forcing ravens to rely on scavenging and, for group-roosting non-breeding birds, to tell each other when and where carrion is located. In the north, it pays for ravens to communicate and cooperate.

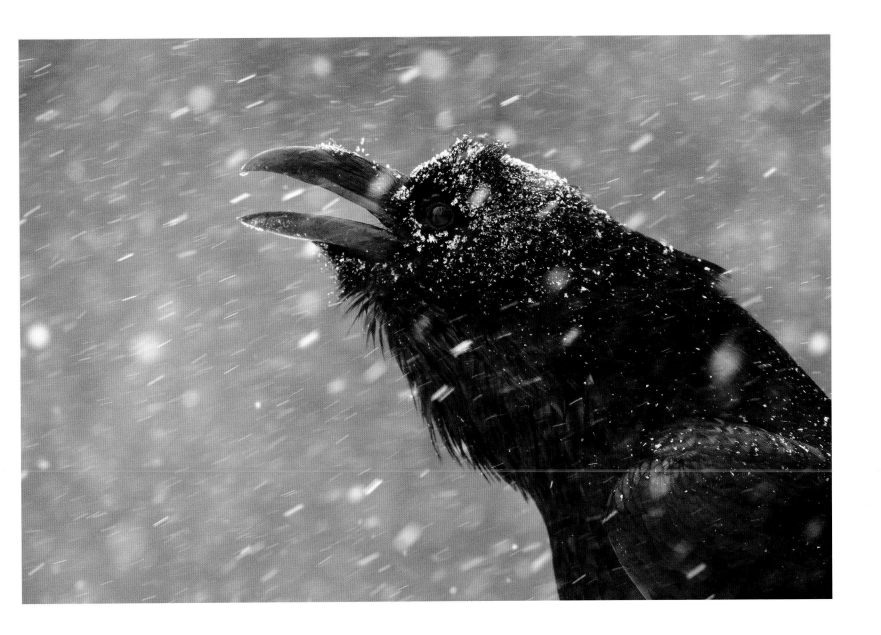

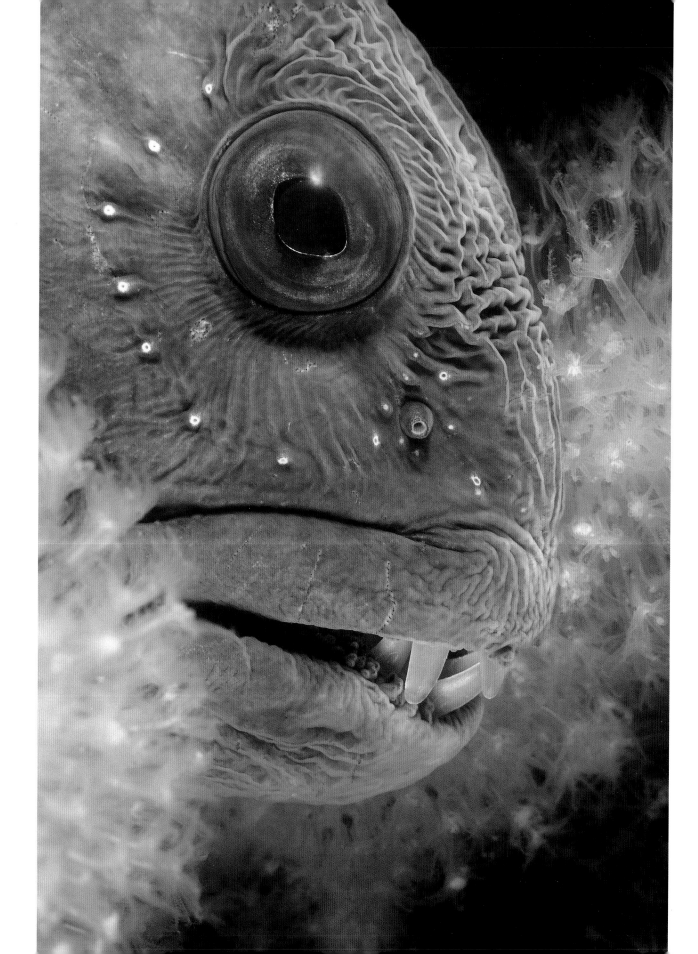

GNASHER

Espen Rekdal

There can be few animals with such a shell-cracking, bone-breaking mouthful of teeth as an Atlantic wolffish. It has the jaw muscles to match, within a head that takes up a large part of its eel-like body. This relatively small adolescent – just 60 centimetres (2 feet) long – is portrayed poking out of its rocky lair, framed by a ruff of the filter-feeding polyps of dead man's fingers (soft corals). Its feeding ground is a deep abyss between islands off the coast of southwest Norway, where strong currents bring in plenty of food for the wolffish's hard-shelled prey, including mussels, sea urchins and crabs. Visible are just some of its canine-like teeth – six in its top jaw and either four or six in its bottom one. But behind them is a full mouthful of crushing gnashers – three rows in its palate and two rows in its lower jaw, plus a scattering of serrated teeth in its throat. It seldom has to chase its prey, but it can swim in an undulating way, without pelvic fins, using its two large, rounded pectoral fins, which it can also rest on like great hands. With such a fearsome appearance, the wolffish is surprisingly attentive when it comes to courtship and its nursery work. In a process that may take hours, a pair will mate in a most unfish-like manner, vent to vent. The female then lies on her side to produce the internally fertilized, comparatively large eggs. She pulls them together in a clump and waits for several hours until they swell and their membranes harden. They are laid at the end of summer or in the autumn, depending on the particular North Atlantic region. It is the male, though, that mainly guards the egg cluster and then the larvae when they hatch in spring, which means a relatively sedentary period for four months or more. Antifreeze in the wolffish's blood helps it cope with low sea temperatures, but winter is a period of comparatively little feeding – the ideal time for dental repair. But rather than replace worn-down and broken teeth, the wolffish chooses the simplest option – it just discards all its teeth and grows a full new set.

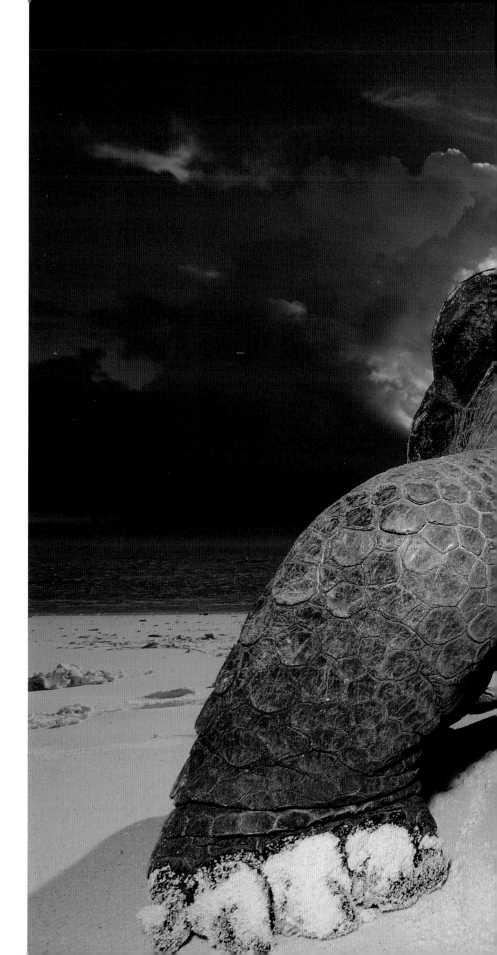

GIANT BEACHCOMBER

Thomas P Peschak

This is a portrait of a true giant of a reptile, taken in the one place in the world where giant reptiles rule – Aldabra. There are now more than 100,000 Aldabra giant tortoises on this remote Indian Ocean atoll, part of the Seychelles, where the only humans are rangers and scientists. Lumbering across the beach, foraging for seedpods, this female is more than a hundred years old and nearly a metre (3 feet) long. With no predators, she is afraid of nothing except the extreme heat of the day. Her normal habit is to graze on the 'tortoise turf' herbs and grasses of this particular island – Grande Terre, one of four comprising the Aldabra atoll – but she does so only in the early morning and late afternoon. Tortoises warm up and cool down with their environment. They can't sweat and can lose heat only through their exposed skin and by panting. Indeed, the need to avoid overheating, together with a lack of predators, is believed to be the reason why Aldabra giant tortoises have a much larger opening under the shell, compared to giant tortoises on the islands of the Seychelles itself and on the Galapagos. But finding shade in the heat of the day is the only reliable way to avoid dehydrating and cooking in their shells. The lucky ones get to squeeze into caves on the island, but for the others, it's a life-or-death need to have a bush or a rock to shelter under.

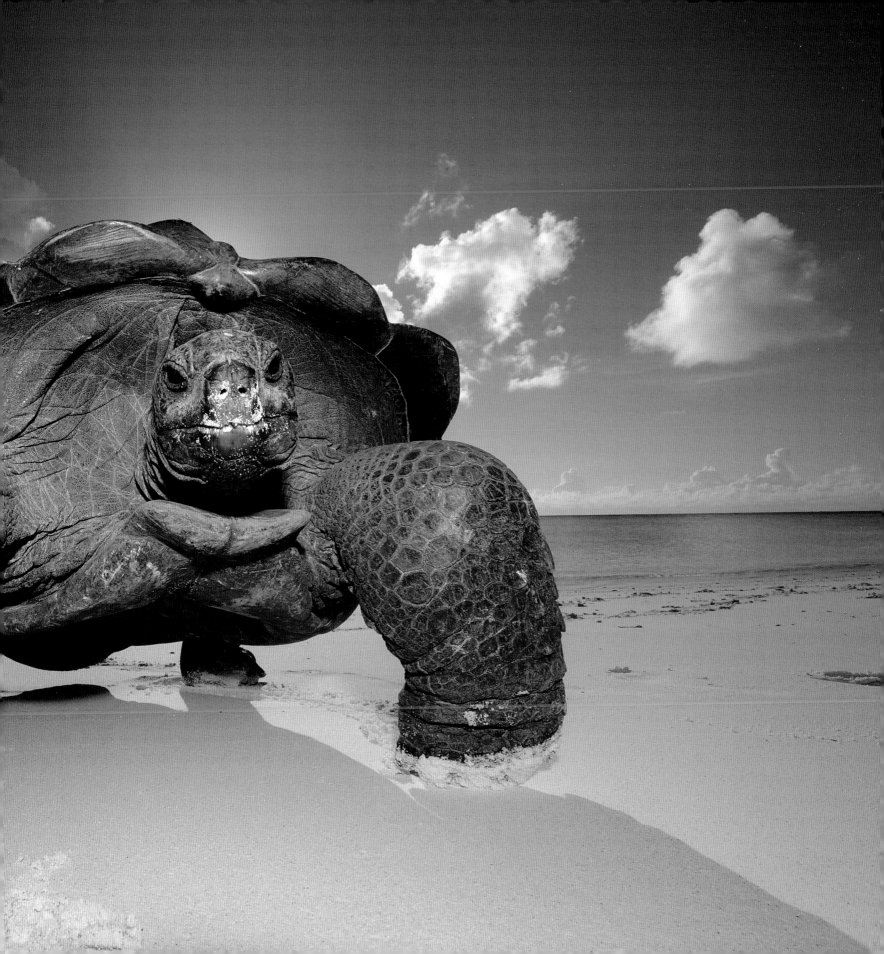

SIX-FOOTERS SIZING UP

Robert and Virginia Small

The pose is one of strength as well as height. These male western diamondback rattlesnakes are sizing up, vying for height with a vertical extension of at least a third of their body length, before entwining, wrestling and trying to force one another to the ground. The location is the Rio Grande Valley in south Texas, on a warm April morning. The combatants were probably straight out of winter hibernation – most likely from a communal den that they were sharing with each other as well as other males and possibly females. Indeed, at least one female was almost certainly nearby, watching the contest. Each male was more than 1.8 metres (6 feet) long and obviously very powerful. Over and over they would raise up, their lower bodies entwined, and try to outdo each other in height. Then they would rapidly wrap around each other, pushing and straining for minutes at a time as they tried to force each other to the ground, finally hitting the earth with a loud whomp. The photographers watched the combat dance for more than half an hour until the slightly smaller rattlesnake finally gave up after being slammed down once too often. It quickly untwined and slithered away, leaving the dominant rattlesnake free to court any watching female. Even after such a show, a female may not be receptive to his size or advances, forcing him to court her over days or even weeks. Though the largest, most dominant males will be able to guard females in their home ranges against the attentions of other males, both in the spring and autumn mating seasons, they don't necessarily father all the young. Indeed, genetics reveals that a litter of baby rattlers may have several fathers. So though size obviously matters in the rattlesnake stakes, a small sneaky snake can still achieve paternity.

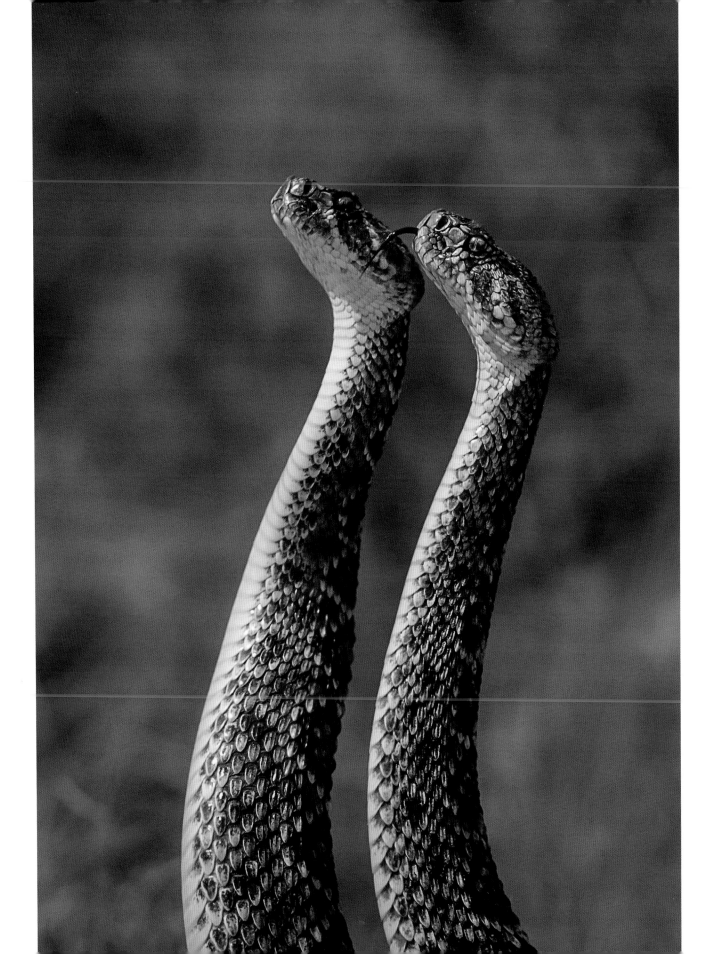

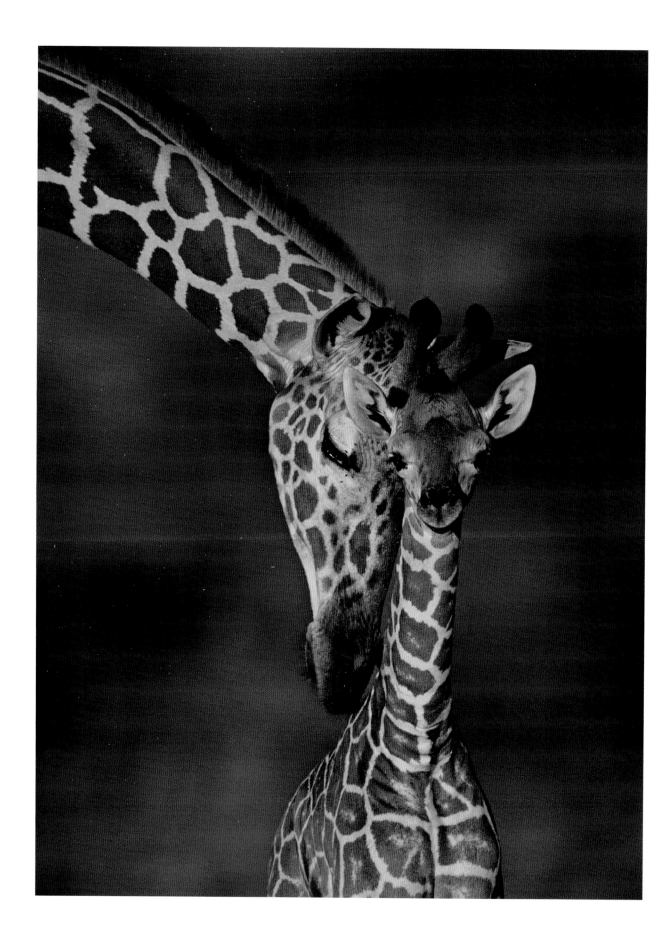

THE GREETING

Karl Ammann

This is an intimate portrait of a reticulated giraffe calf, just a few weeks old, being greeted by, most probably, an aunt as its mother introduces it to the family herd in Samburu National Reserve, northern Kenya. The aunt nuzzles it and rubs it with her head. Other females and young giraffes have also gathered to make its acquaintance. The calf's mother gave birth in a patch of savannah woodland not far from the group but with enough cover to keep the calf hidden while she moved away to feed. In dappled light, the calf's reticulated pattern – paler than an adult's – will have helped hide it from lions and other predators. And predators are the main reason that more than half of giraffe calves never reach adulthood. When the mother gave birth, she was standing up. Having survived the long drop, the calf would, within 30 minutes, have been standing up, too, and suckling. Already more than 1.8 metres (6 feet) tall, it will double its height in just a year and will continue growing until it's at least four years old, reaching a height of more than 5 metres (16 feet 5 inches) if a male and more than 4 metres (13 feet) if a female – giraffes are the world's tallest land mammals. The calf's tiny, tufted horns lie flat against its head but will slowly stand up as bone replaces cartilage. It is part of a herd of females and young that are a sub-unit of a much larger community of groups spread out over a large range. Young males form bachelor groups, but adult males tend to be solitary. When they join the females, it will usually be to mate, but among each other, they will spar, using their long necks as weapons. Like elephants, giraffes use infrasound (low-level sound beyond human hearing) to communicate, possibly keeping track of each other over large distances and at night. It's a connected community that the calf will be part of for life.

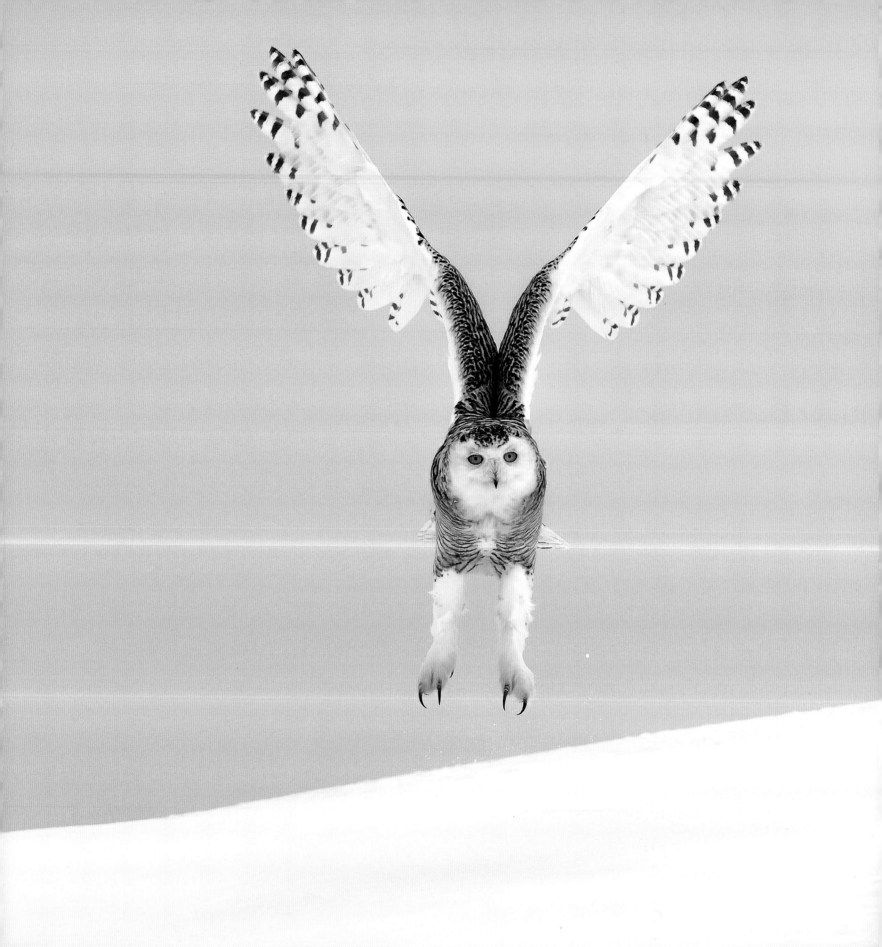

SNOWY LANDING

Vincent Munier

Huge wings sweep around, feathers splayed, as a snowy owl prepares to touch down. Set against a snow-grey sky, the owl displays both its precision-landing technique and its grappling-hook talons. The winter setting is typical – snow-covered tundra-like grassland – but this is not the Arctic, rather a windswept prairie in Quebec, Canada, where the owl has set up a temporary hunting territory. This is a young female – larger than a male and distinguished by her heavily barred plumage. She has moved south of the Arctic Circle in search of ground with a snow depth of 30 centimetres (12 inches) or less, which she can pounce through. With layers of feathers, including an undercoat of down, and thickly feathered feet, her plumage gives her insulation equivalent to that of an Arctic fox. And being large – the snowy owl is North America's heaviest owl, standing more than 60 centimetres (2 feet) tall – her reduced ratio of surface area to body size also helps her conserve heat. Though she can catch prey as large as a hare or a sea duck, her normal diet is small rodents, mainly lemmings. Lying on the snow, the photographer has been watching her use her sit-and-wait hunting technique, swivelling her head to scan the surroundings, listening with her acute hearing for rodents scurrying under the snow, then gliding and pouncing. If the snow becomes too deep or the icy crust too thick to break through, she might prospect for hunting grounds farther south, returning north in spring to the Arctic Circle and increasing hours of daylight hunting.

QUEEN OF THE PHILIPPINES
Klaus Nigge

There can be few birds as impressive as a Philippine eagle, the world's largest eagle. But it is also the world's rarest eagle, with no more than 500 mature individuals remaining, and few photographers have managed to take a portrait of it in the wild. Here a metre-tall (3-foot) female rests on a favourite perch high in the canopy of mountain rainforest on the island of Mindanao. It's the perfect pose. In the relative cool of the morning, her breast feathers are puffed up, their colour blending with the light-coloured bark of the trunks and main branches of many of the forest trees, while she scans the trees for prey such as roosting flying lemurs, civets or monkeys. The portrait shows how her huge black beak takes up much of her face, and with her neck feathers partially raised, she appears to have an expression of mild curiosity as she stares at the photographer's tree hide. If her feather ruff were to be fully extended, it would effectively double the size of her face, resulting in a fearsome stare. But what is truly terrifying is the future for this critically endangered species. A pair of Philippine eagles mate for life but breed every two years at the most and need a large area of forest to successfully rear a single chick that doesn't mature until it is five to seven years old. And even though the species is protected by law and celebrated as the national bird, individuals continue to be killed. But the biggest threat remains the logging of the forest that the eagles need for their survival.

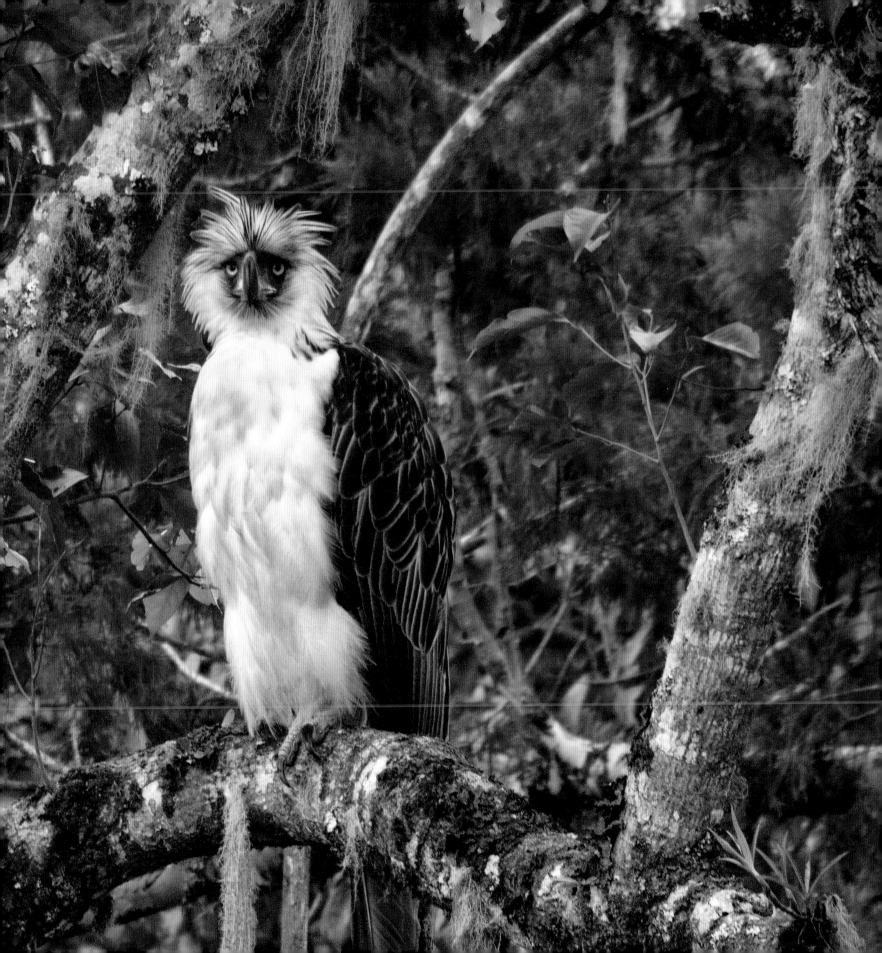

THE LICHEN LOOK
Pete Oxford

Sporting camouflage accessories, including lichen-like encrustations and moss-like crinkled antennae, a male katydid poses on a twig that matches his ensemble perfectly. Such exquisite camouflage means that only the most dedicated of nature photographers could locate it for portraiture. The species is one of hundreds of katydids (bush crickets) to be found in the forests of South America. This one is in Ecuador, in a cloud forest on the western slopes of the Andes. Most katydid species are expertly camouflaged among vegetation to avoid the multitude of predators, and many of them have yet to be identified. The male here not only matches the colours of his background, but he has body parts masquerading as elements of moss and lichen that disrupt his outline. He has also expertly positioned himself to perfect the disguise. To find a female for procreation, a male needs to call her in, but to avoid detection by daytime predators, this katydid sings at night. By rubbing together his forewings (one equipped with a scraper and the other a file) he can produce a range of captivating vibrations, with frequencies that can even extend into ultrasound – another way to try to avoid detection. In the equatorial forests of Ecuador there are no seasons, and mating can occur year round. But as typical weather in the Andes can involve prolonged cloud cover and frequent rain, the equatorial advantages are offset by the inevitable drop in night-time temperatures, which quickly cool a katydid's ardour. The big disadvantage of a hide-and-seek lifestyle is, however, its extreme specialization. Such niche-specific camouflage limits the places where these katydids can live. Also, if the humidity necessary for a rich moss and lichen fauna should decrease with a changing climate, these insects could be left high and dry.

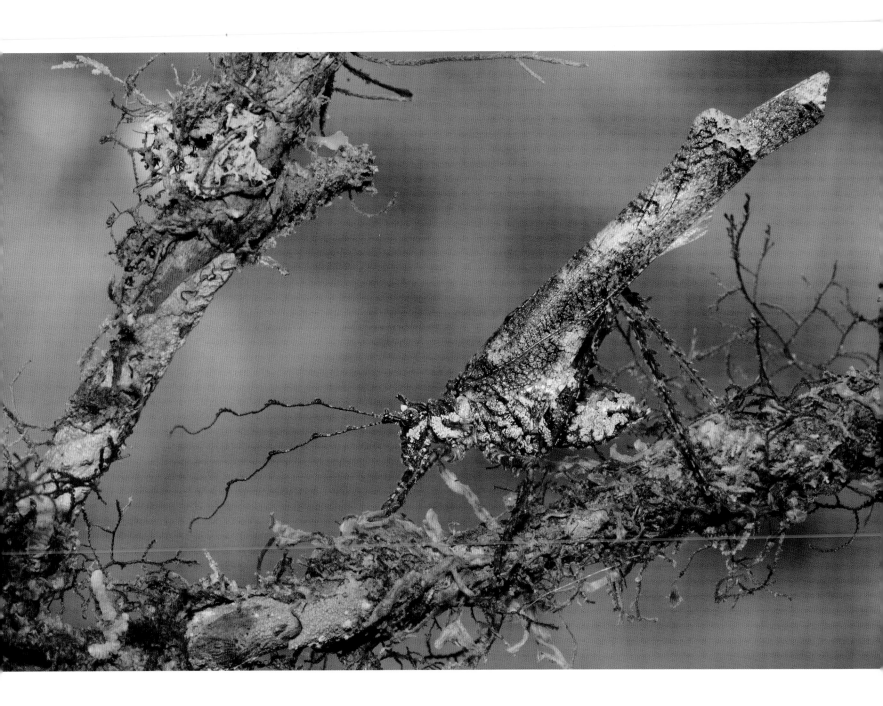

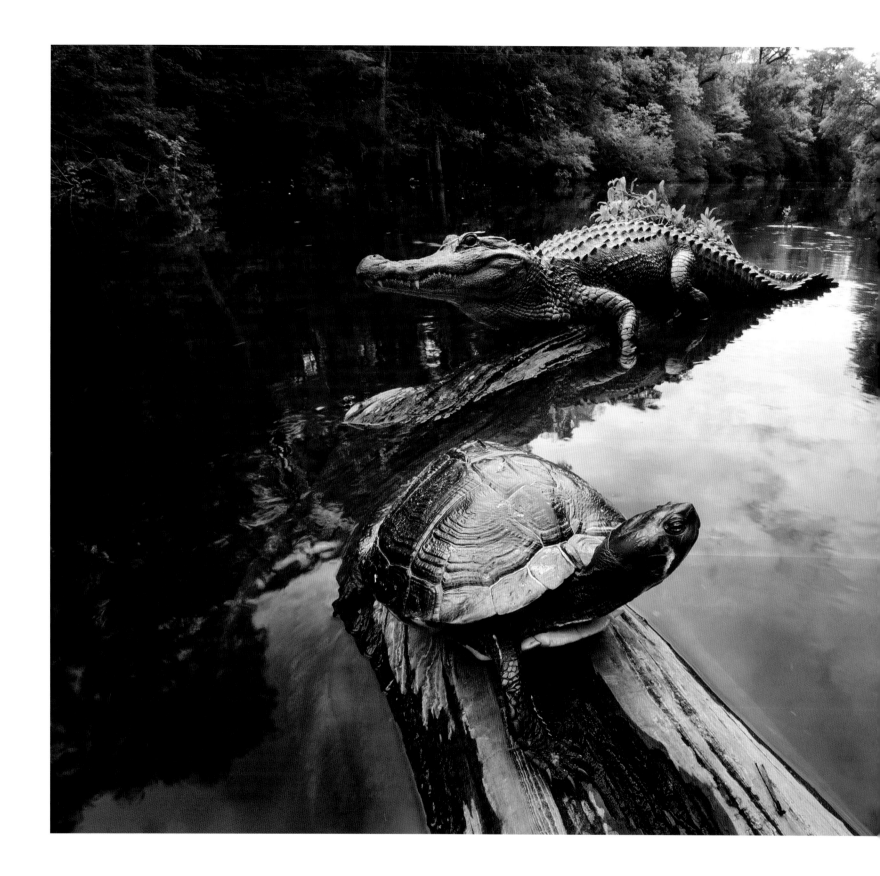

THE ODD COUPLE

Mac Stone

To get going in the morning, reptiles need a sun boost. Good basking spots are in high demand, which can mean crowding up with others – or even risking sharing with a sunbather capable of eating you. Here, in a blackwater creek in South Carolina's Four Holes Swamp, a large female yellow-bellied slider shares a cypress log with an American alligator. It was a portrait that took time to set up. It involved finding a location with a log big enough for several animals to bask on and then mounting a camera on the log, timed to take a picture every 10 minutes. It also relied on solitude, as the skittish sliders would slide into the water at the slightest unusual sound. Warming-up took place in the morning, presumably to help the reptiles get moving after a cold night in the water, but warmth is also important for digestion and, in the case of a female terrapin like this one, for egg development – worth the risk of cohabiting on a log with a predator. Alligators will eat sliders, especially the young ones, and a big alligator is capable of crunching even a big female. But in a swamp rich in alternative alligator prey such as fish, crayfish and amphibians, the two species can live side by side.

SEAHORSE IN REPOSE

David Hall

Curled around a frond of giant bladder kelp, the female pot-bellied seahorse coyly turns one eye to the photographer. Artificial lighting has created a stage set in yellows and greens, the kelp curving around the spotlit model, its blades rimmed with translucent teeth, its flotation bladders glowing orbs. But without the light, in the gloomy depths of the Tasmanian kelp forest, the stance, colour and silhouette of the seahorse provide camouflage as she rests, anchored to the frond with her prehensile tail. Her upright pose is typically seahorse, and though she is a mere 13 centimetres (5 inches) high, pot-bellied seahorses are among the world's largest and can be up to 30 centimetres (12 inches) high. Her 'belly' – the area of the junction of abdomen and tail, here hidden by the kelp – is relatively flat compared to that of a male. There is no actual stomach. So seahorses eat almost continuously, sucking up tiny animals such as brine shrimps at close range through their tube-like snouts. Yet a male does have a pot-belly. It's his brood-pouch – effectively, a womb. Mating involves the female inserting hundreds of eggs into it, where they are fertilized and then embedded into the wall. Special fluid delivers nutrients and oxygen to the young, which are born after a few weeks, usually on the night of a full moon, as miniature replicas of the adults. Though pot-bellied seahorses can manoeuvre expertly with their four small fins – one each side of the cheeks, one under the belly and one at the base of the tail – they are not fast swimmers. And though their prehensile tail is useful for hanging onto floating objects, in stormy weather, huge numbers die. But it is their appealing body shape and bony frame that lead to the greatest number of deaths. Not only are more than a million seahorses of all species sold as dried trinkets, but also more than 20 million and possibly as many as 120 million a year are consumed as part of Chinese medicine.

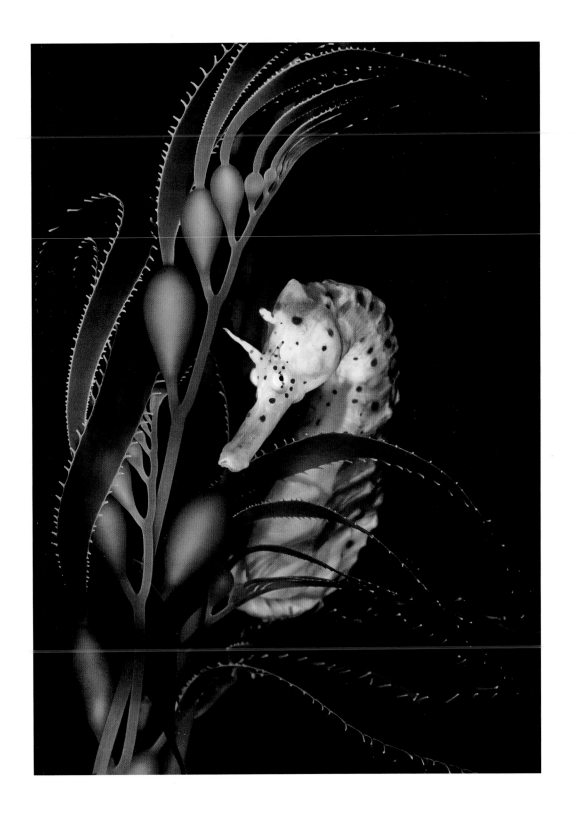

VOLE IN A HOLE

Danny Green

The drainage pipe seemed the perfect vole-sized hole, but it took the photographer very many days camped on the opposite side of the canal before he saw a water vole that thought the same. The canal in Derbyshire is disused, but has banks ideal for these large voles: steep but easy to burrow into, not overly shaded and with a rich mix of succulent grasses, sedges and flowering plants, together with aquatic plants, providing plentiful cover and food – and relatively shallow, still water to dive into as an escape route. It was the perfect urban refuge. The only problem was a risk of burrows flooding when it rained heavily. Water voles might favour living beside water, at least in England, and can swim, but they are not aquatic rodents. They don't have webbed feet, and their fur becomes waterlogged if they are forced to remain in the water for long. Luckily for this population, the council lowers the water table if flooding is anticipated, not wanting the canal to overflow. Elsewhere in Britain, however, the threats are great. Rather than flooding, it is wetland drainage, dredging, river and stream canalization and the extension of arable cultivation and livestock grazing right to the river edge that have caused water voles to vanish from nearly 90 per cent of their former range – the most dramatic decline of any British mammal. It's a situation that has been compounded by predation by feral North American mink, which being semi-aquatic can catch voles if they try to escape into the water and, in the case of the smaller females, can even squeeze into their burrows. So the water vole featured in this prize-winning portrait represents one of the few lucky populations in the UK, its canal site now protected as part of a reserve.

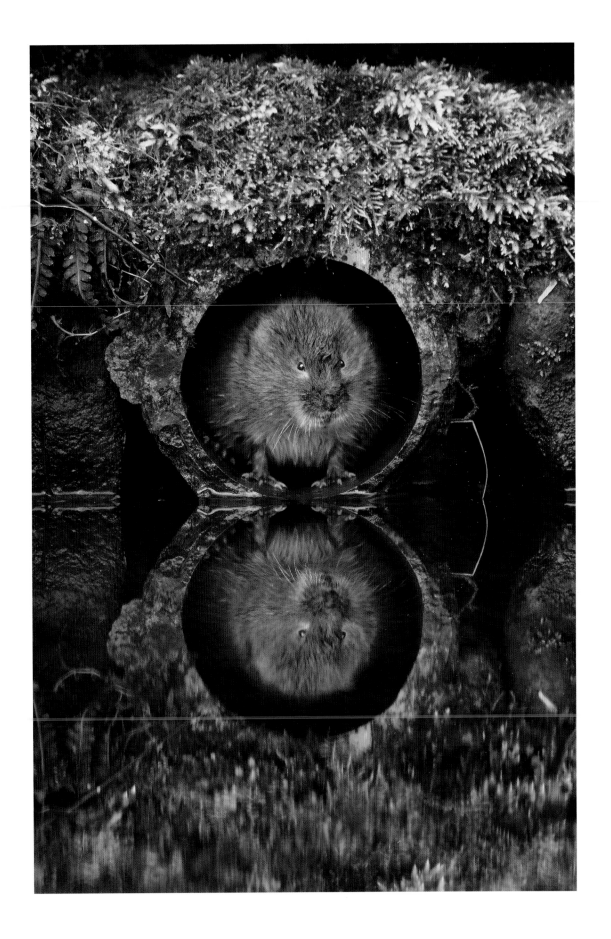

FINAL LOOK
Steve Winter

This is an extremely rare portrait of the extremely rare Sumatran tiger. It is one of only two images obtained after months of frustration. Taken in Gunung Leuser National Park in the north of the island, it shows a male patrolling his territory. Smaller than a Bengal tiger, he also has a distinct mane and a coat of a richer colour, with more black stripes closer together. The last of the Indonesian island races – the Javan and Balinese tigers having become extinct half a century ago – the Sumatran tiger is critically endangered, with only 500 or so remaining. The main problem is the continued fragmentation and loss of its forest refuges to oil-palm and acacia plantations, leaving just a few areas large enough to hold viable tiger populations. But tigers are also still persecuted and poached for their body parts, which means they are extremely wary and usually active only between dusk and dawn. After many weeks of carefully setting up camera traps and getting nothing, the photographer persuaded a poacher turned forest guard to help him. Of the seven cameras he placed, two were stolen and just one was successful. Both precious frames were taken at a carefully chosen spot, where three tree buttresses provided the right backdrop and the camera could be positioned so the tiger would be centre-frame. Three lights were positioned on a tree above the camera. But the magic touch came from the tiger itself. Perhaps noticing a glint of the moon in the lens, he turned its head just at the moment he triggered the beam, creating the unforgettable head-on portrait.

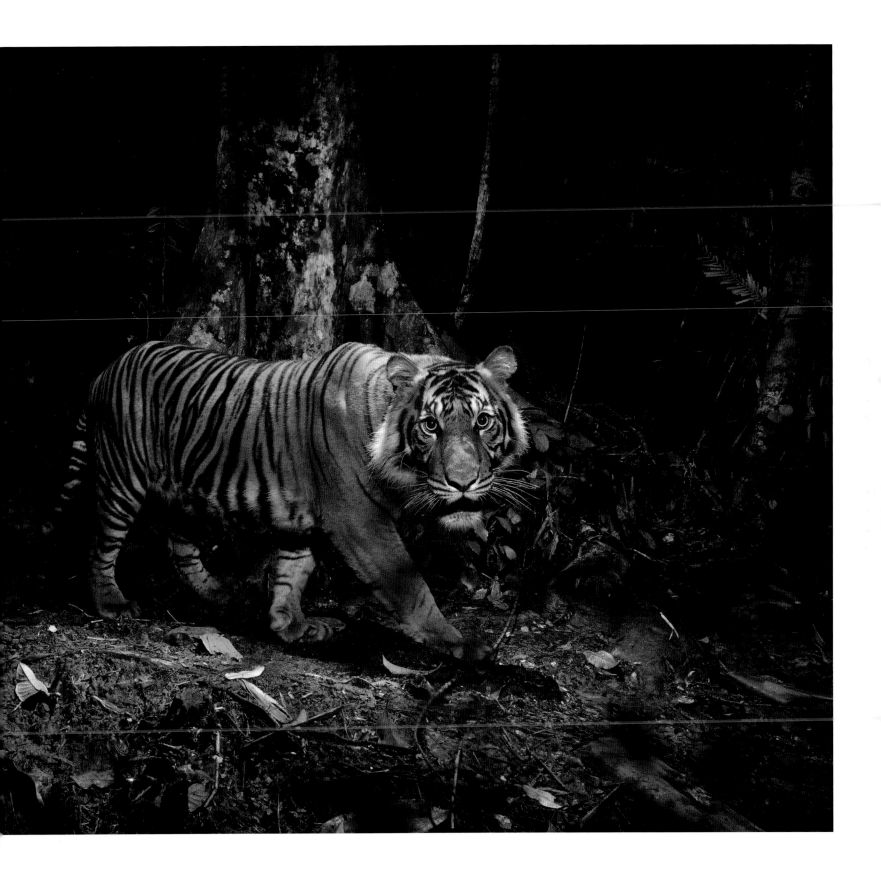

MATRIARCH
David Lloyd

If the function of a portrait is to memorialize a living individual, then this is
one such image. Borrowing a technique from mainstream portrait photography,
it uses the power of light and shade to emphasize the wear and tear that gives
expression and history to the face. The elephant – a relatively young matriarch in
Kenya's Maasai Mara National Reserve – is an experienced mother who is leading
her group across the plain to a waterhole for a drink and a bath before sunset.
The power of the portrayal is enhanced by the crop, focusing attention on her
amber eye and the sweep of her tusk. The low evening light has burnished her
skin with a glow, and the shadows outline every crease and crevice. It's a simple,
respectful portrait of a magnificent animal.

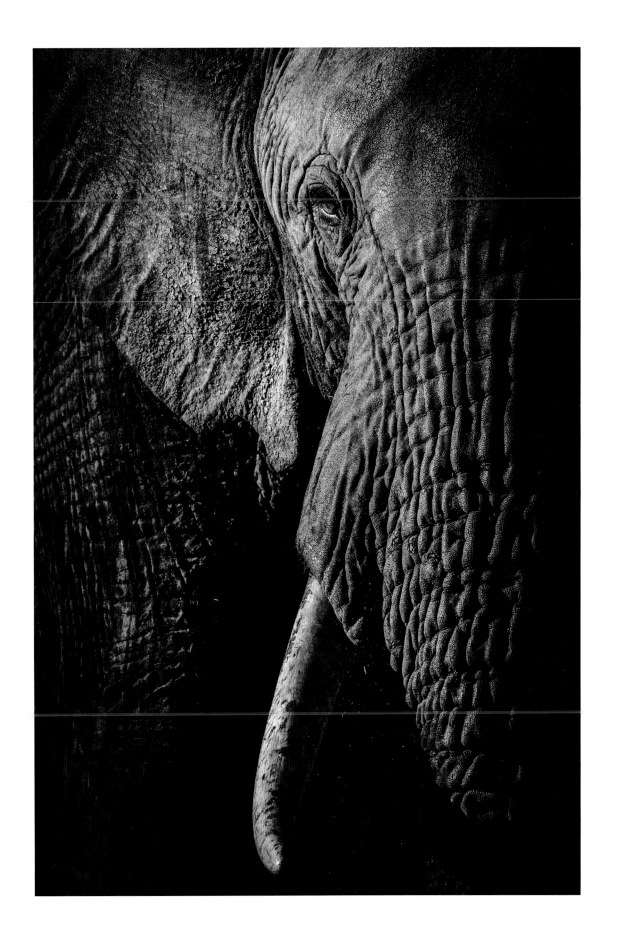

COOL CAT
Isak Pretorius

A head-on penetrating stare – the classic portrait of a predator. But the eye-level view and the frame of lush greenery makes this image uncomfortably different – as if the lion has been unexpectedly found drinking from a pond at the bottom of the garden. The waterhole is, of course, in Africa, in Zambia's South Luangwa National Park, and the photographer achieved his shot by anticipating that, after sleeping off a night feast of a buffalo kill, the lioness would need to drink, and he knew just where she would go. So though there was an element of luck in being able to see the precise point where she emerged through the rainy-season grass, there was nothing lucky about the composition or the timing – catching both her forward glance and her lapping tongue. The low angle was achieved by using a long lens from a vehicle positioned on the opposite side of the waterhole, making use of the early morning light to bring out the rich colours. The result is a strikingly original portrait of one of the most photographed of all African animals.

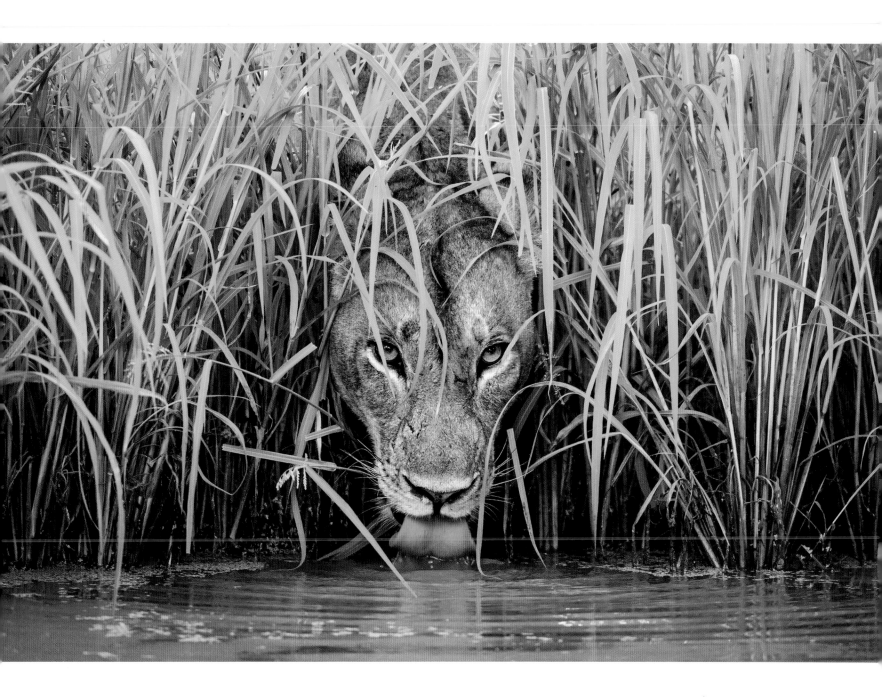

THE BIRD THAT ISN'T THERE

Jess Findlay

This is a pauraque, portrayed as it would like to be seen when asleep – as a background mix of earthy colours and patterns. Such cryptic camouflage is what enables it to rest on the ground during the day, blending with the leaf-litter and debris. It incubates its eggs on the ground without bothering to build a nest, and its chicks are equally camouflaged. Only at dusk does it become airborne, hunting night-flying insects, snapping them up or hoovering them with its huge gape. A reflector at the back of its eyes – the tapetum, which also gives it its characteristic coal-red eye-shine in headlights – means that it can hunt in low light, spotting its prey silhouetted against the sky. And when the moon is full, it will hunt from dusk to dawn. The photographer went in search of a pauraque in dry woodland in the Rio Grande Valley, southern Texas, the northern limit of its American range. But so perfectly did this nightjar blend into the leaf-litter, that only by homing in on the whistling of a male at night was he able to know where to look for it. Even then spotting it took a while – if a pauraque senses movement, it remains frozen in position, only at the very last moment sprinting off on its tiny legs or flying up. This close-up – photographed from a distance with a long lens – reveals the complex pattern of feathers, which include the neck ruff and wing coverts. Hidden are white feathers that are exposed in flight and used for display. Each individual has a unique mix of colour and patterns, and it seems likely that they somehow 'know' what they look like and choose to sit where the background best matches their own unique markings.

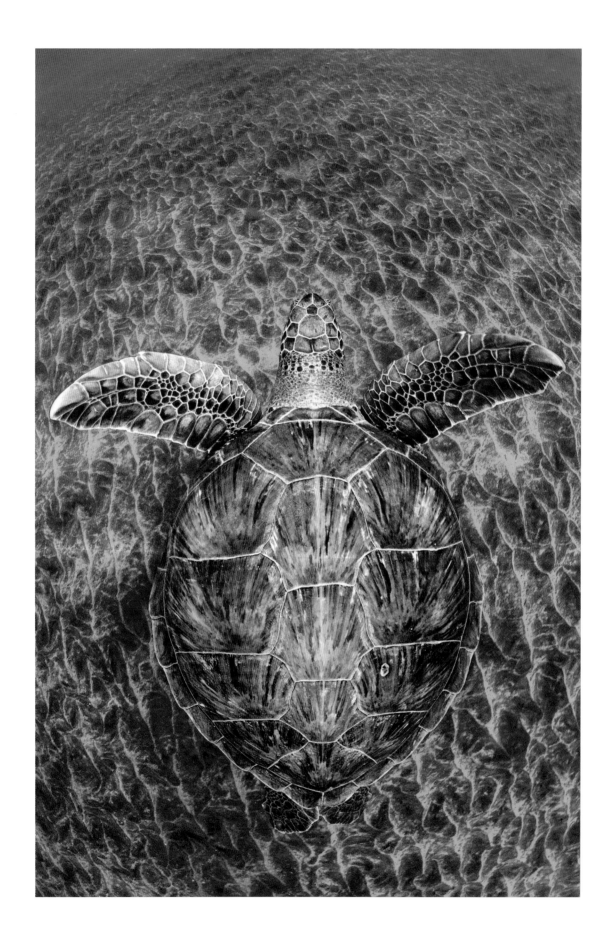

TURTLE JEWEL

Jordi Chias

In a frame of blue water over black volcanic sand, the oval shell of a young green turtle almost glows with a brush-stroke mix of colours – its individual signature. Four non-overlapping plates on each side of the shell and a single white claw on the leading edge of each front flipper identify it as a green turtle. For the photographer, the species is a true marine treasure and his favourite subject for marine portraiture. This youngster is sculling across a shallow bay off Tenerife, in the Spanish Canaries, heading for a meadow of seagrass. It's mainly herbivorous, feeding on seagrass and algae, which colours its fat green and gives it its name. A beak with serrated edges crops the vegetation, and a capacious large intestine helps digest it. It will also snack on jellyfish, salps, sponges and the occasional small fish. In fact, for its first three to five years, it was entirely carnivorous. This was when it travelled the high seas, from its birthplace on the coast of Africa or even Central America, probably using the Gulf Stream to help it cross the Atlantic to the coast on the other side. The movements of green turtles in all of the world's tropical and temperate oceans are still mainly a mystery, and the places where they hang out during their oceanic phase are mainly unknown. But when they are mature enough to breed, green turtles use the Earth's magnetic field to migrate back to their birth beaches – in the case of females, returning to lay eggs every few years. Like nearly all sea turtles, the green turtle is endangered, with human pressures at every stage of its life. These pressures include egg collecting, hunting, loss of nesting beaches and drowning in drift nets or on the hooks of long lines or in shrimp trawls. In the Canary Islands, the turtles are endangered by boat strikes, pollution, entanglement in nets and ingestion of hooks and monofilament lines. Yet it's an acknowledged marine treasure – a charismatic tourist draw – but one that needs ever more conservation measures to reverse its decline.

FLASH DIVE

Mario Cea

This is a portrait of an aerodynamic marvel as much as of a truly beautiful bird. It reveals the perfect trajectory of its controlled, high-speed vertical dive down onto a minnow, the electric-blue light trail indicating that it is travelling faster than the eye can follow. As the beak pierces the water, the kingfisher folds in its wings, and a protective membrane covers its eyes. The secret of such a splashless entry into the water is the bird's wedge-shaped, streamlined beak – nearly a quarter of its body length – together with the musculature of its neck, contracted just before impact to hold its position. It also enters the water with its beak slightly open, in preparation to snap hold of the fish. That it can do so with accuracy is because it has seen the target prey from above and knows exactly where and at what depth to strike, aided by vision that allows it to compensate for the refraction and the reflection of light from the water. The natural pool into which this male is diving – once part of a river, near the photographer's home in Salamanca, Spain – has a shallow bend where minnows and other small fish tend to gather at the perfect depth for a kingfisher dive. The photographer planned this image, planting a branch in the pool as a perch for the kingfisher and its mate and setting up his hide to face it. But it would take nearly six months and more than 5,000 attempts to get the shot with the perfect lighting, the perfect position and mirror-still water. An LED lantern lit the scene as the camera fired, and using a slow shutter speed to capture the blurr of kingfisher movement, he triggered four strobes a fraction after the shutter opened to freeze the moment after the blur and as the kingfisher's beak pierced the water.

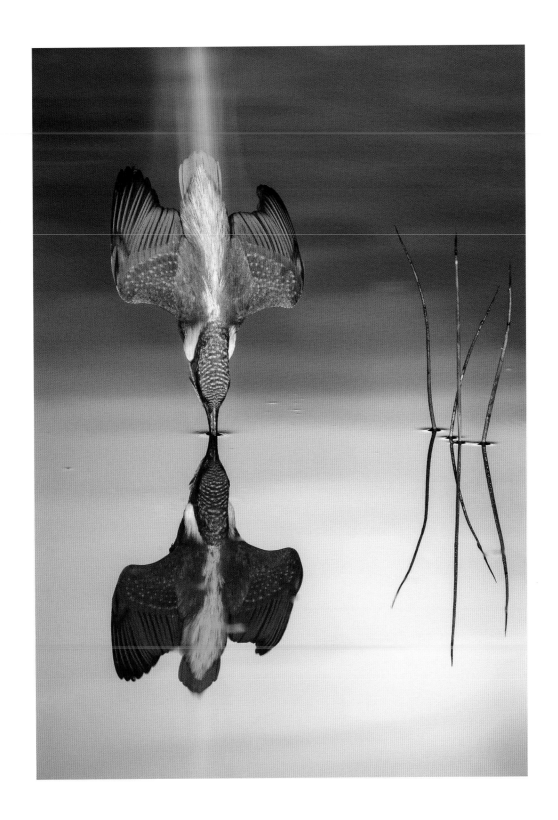

OCEAN BLUES
Jordi Chias

A fleeting moment of perfect alignment creates a double portrait of the blue shark, revealing the elegance of a body designed for the open ocean and the torpedo-shaped sensory snout of a predator that follows its nose. Its long, pointed pectoral fins are designed for agile steering, and while it can twist and turn at speed, a blue shark can also glide almost effortlessly on its long migrations. More than a third of its brain is used to analyse scent trails, both of potential mates as well as food – mainly small and medium-sized fish and cephalopods but also carrion. Its head is also covered with hundreds of pores linked to sense organs that can pick up the electrical fields all moving animals create, helping the shark to zero in on prey. When hunting near the surface in the early evening and at night, a blue shark's huge eyes maximize light collection, as does a reflective layer behind the retina, though vision becomes important only when the shark is relatively close to an object. The cobalt blue of its dorsal skin blends into the blue of the deep when seen from above, and its silver-white underside is equally effective camouflage when seen against a bright sky. But a high-seas disguise is no defence against fisheries. The sharks are found in every ocean and off the coast of every continent except Antarctica and are caught in their millions by fisheries worldwide, both for their fins and sometimes for their meat, but most often as bycatch on long lines set for other fish. The total population of blue sharks is unknown, but given the scale of the catches, it is highly likely that numbers are declining. Here, in the North Atlantic, in deep water off the Azores, many blue sharks gather to feed in both a mating and an open-ocean nursery site – which conservationists want to see protected as a shark sanctuary.

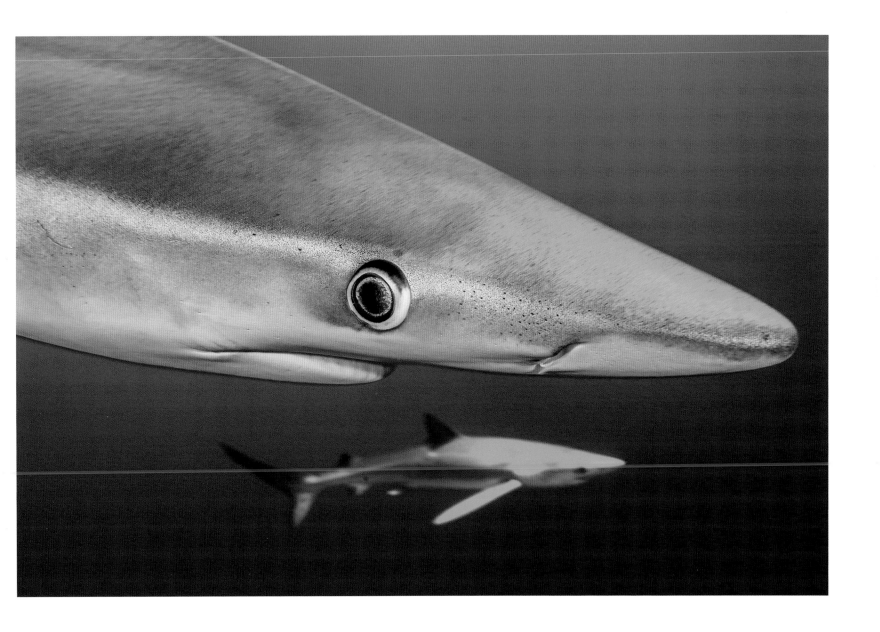

THE ICON

Mervin Coleman

Seldom has an American bison been portrayed with such an aura. Shooting the bull against the rising sun has rimmed the frosted fur of its unmistakable profile with light and the great dome of its head with steam crystals, adding a spiritual element to its magnificence. For the plains Indians that once inhabited North America, the bison had enormous spiritual and physical significance. It provided them with almost everything they needed, and for thousands of years – when the herds numbered in their millions – bison and people were intimately connected. But in the nineteenth century, when the United States and Canada expanded across the plains, the Indians were defeated, and the bison were hunted to virtual extinction. Today there are just five viable plains bison populations and a scattering of small herds, mainly in private ownership. This male is in Wyoming's Yellowstone National Park – the only remaining place where bison have lived continuously since prehistoric times. In 1902, just a couple of dozen animals remained, but today there are about 5,000. This one's herd is wintering in the Lamar Valley, close to hot springs, where there is better access to grass and sedges – the mainstay of a bison's diet. But snow still covers the ground. The bison copes by using its hump – the large neck and shoulder muscles. Swinging its head from side to side, it shovels the snow aside, and where groups gather to feed, the snow furrows made by the bigger animals help the smaller ones by clearing a way for them to feed. The herd will also defend the young, and their strength and stature make them powerful adversaries for predators without guns.

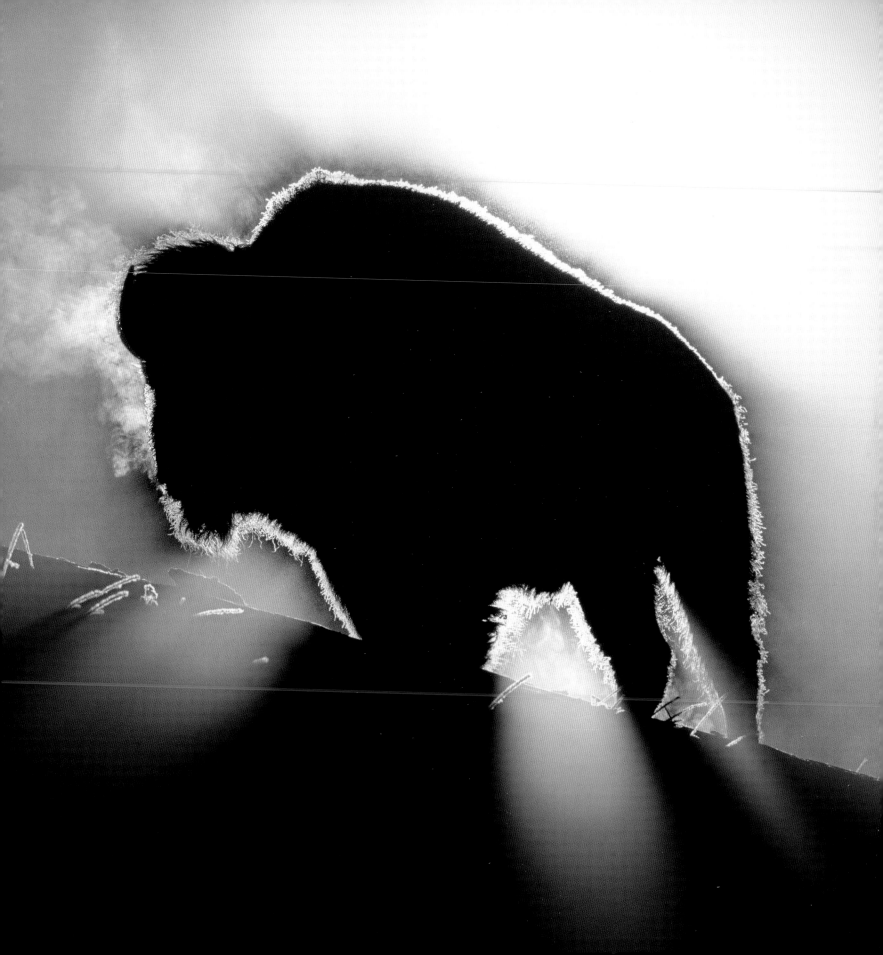

CUB WITH CHARACTER

Wendy Shattil

Spotlit in summer sunshine, a young fox cub poses, looking straight at the photographer. The result is an award-winning portrait of an American red fox, perfectly composed, in a soft-focus frame of green grass. This youngster is the boldest of a litter born in a den at the bottom of a garden in Denver, Colorado. Whenever the photographer set up her 800mm lens at the top of the garden, always in the late afternoon, this cub would be the first to show itself, sitting for a moment to watch her. The likelihood is that it was actually one of the most subordinate cubs in its litter, missing out on competition over food brought back by the adults, and so forced to be bold to make the most of any opportunity. It may already be foraging farther afield than its more dominant siblings, looking for easy-to-find food such as earthworms, insects and fruit, and only just beginning to learn how to catch rodents. Being low in the ranking may mean it will have to travel farther away to gain its own territory. Though being bold would seem to be a useful personality trait, bold cubs have a far greater chance of being killed, predominantly by traffic, perhaps when crossing unfamiliar roads, and to a lesser extent by dogs or other animals or by misadventure, for example, being caught in a fence when exploring. But for this bold youngster, on this summer afternoon, the trials of life will just involve fun and games, romping with its siblings at the bottom of the garden.

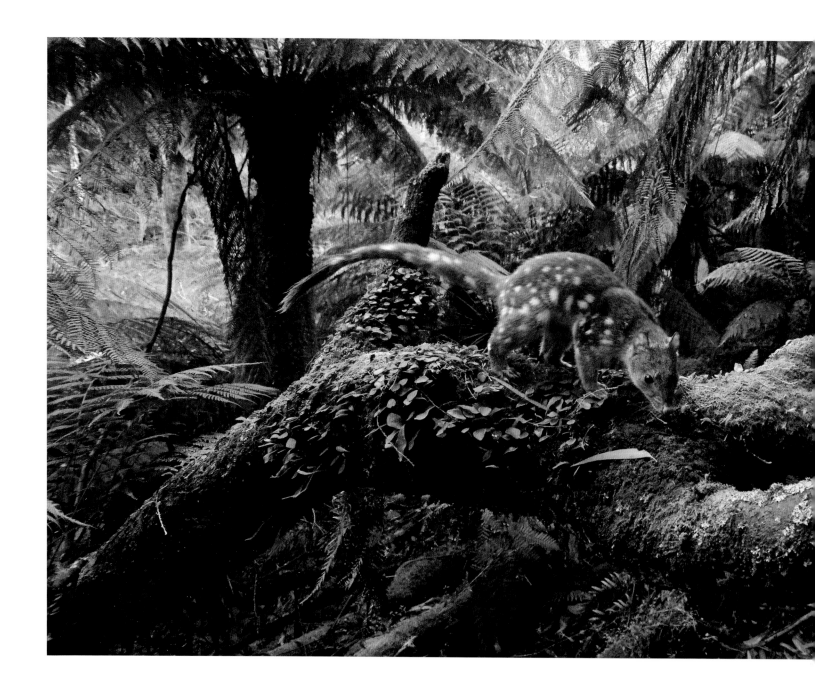

THE QUOLL AT HOME
David Gallan

The aim of this portrait was to show the subject as an integral part of its environment. The spotted-tailed quoll, or tiger quoll, is the largest marsupial carnivore still in existence on mainland Australia. It is also a symbol of the old-growth forests of the southeast. Determined to photograph what, from his childhood, had seemed an almost mythical animal, the photographer took three years to find a location – temperate rainforest on the coast of New South Wales, in Monga National Park. Then it took another six months to find a regular spotted-tailed quoll trail and, along it, the ideal spot for his camera-trap – a moss-coated log bridging a stream, with a backdrop of tree fern fronds. Using just natural light, so as not to scare his subject with flash but also to show the rich forest colours, meant relying on the quoll being active at least for part of the day, which this female was. Quolls hunt in the understorey, catching insects and mammals, and climb in search of tree-nesting mammals including gliders and possums. But though they are opportunistic hunters, they need large territories to provide enough prey and den sites. They also need the forest to be free of introduced foxes, dogs and cats, which compete for prey and kill their young, and free of poison bait put out to kill feral animals. But the biggest threat remains the continued loss of Australia's mature native forests, which outside protected areas, are still being intensively logged to provide woodchips for export.

THE ART OF CAMERA-TRAPPING
Steve Winter

Planned as a diorama – with a Himalayan mountain backdrop, snow and, centre stage, the holy grail of big cats – this was a portrait that the photographer conceived and executed with precision. Not only is the snow leopard elusive, with possibly fewer than 4,000 and no more than 6,500 surviving in the whole of its range, but it is a master of camouflage. So the only chance of anything other than a snatched shot was to use a remote camera. The total shoot took more than a year of planning, the help of many people and months of work at high altitude in Hemis National Park in the Ladakh region of India. To have any chance of the shot he envisioned, the photographer had planned and practised the art of camera-trapping to perfection. Having found an ideal backdrop, he would choreograph the scene – trying out likely poses of any snow leopard stopping at the scent-message rock – so he could plan exactly where and at what distance to place the camera and, just as important, where to place the flashes to light the scene. To find possible locations required the help of locals and researchers and setting up remote cameras on likely trails – 14 cameras, in position for 10 months. Only males would stop to spray, and from weeks of monitoring the camera, it became obvious that this individual not only came at dusk when the sky was still light but would also make the same moves – sniff, turn around to face the camera, put his left paw on a rock, raise his long tail and spray. This enabled the perfect positioning of the lights and the perfect exposure. The perfect portrait was recorded as taken on 12 March 2007 – the photographer's birthday.

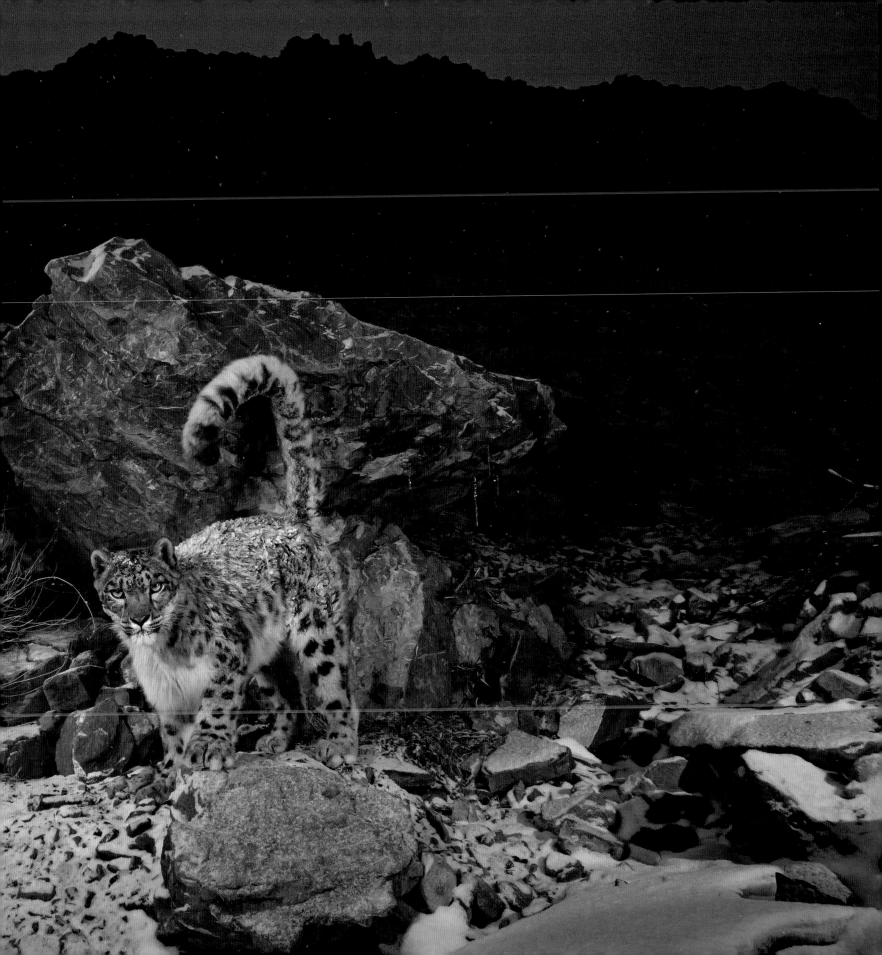

THE SURVIVALIST
Sergey Gorshkov

The silver birch trunk provided the ideal frame for the wolverine, now displaying not only her snowshoe paws and powerful claws but her individual chest markings. She had climbed into the fork of the tree to get a better look at the photographer, waiting for him to retreat to his cabin so she could return to the feast below. The carrion bonanza was the thawing carcass of a bear that had failed to put on enough weight to survive the winter on the Russian Kamchatka Peninsula. She wasn't the only one at the meal – four other wolverines had also located the carcass. It took just three days for them to eat it, crunching the bones with their powerful jaws. That they had found the carrion is testament to their inquisitiveness and their acute sense of smell, as wolverines are solitary, and at least some of them would have been some distance away. But then the winter survival strategy for wolverines is to locate carrion, which means travelling huge distances in search of food. And when they do find a body, they must of necessity eat as much of it as they can and stash what they can't. They also catch any live prey they encounter, whether ground squirrels and snowshoe hares or an injured or snow-bound deer, and they may also try to appropriate the kills of other predators, even wolves, which has helped build the reputation of this, the largest in the mustelid family – larger than a mink or badger – as a bold and fearsome carnivore.

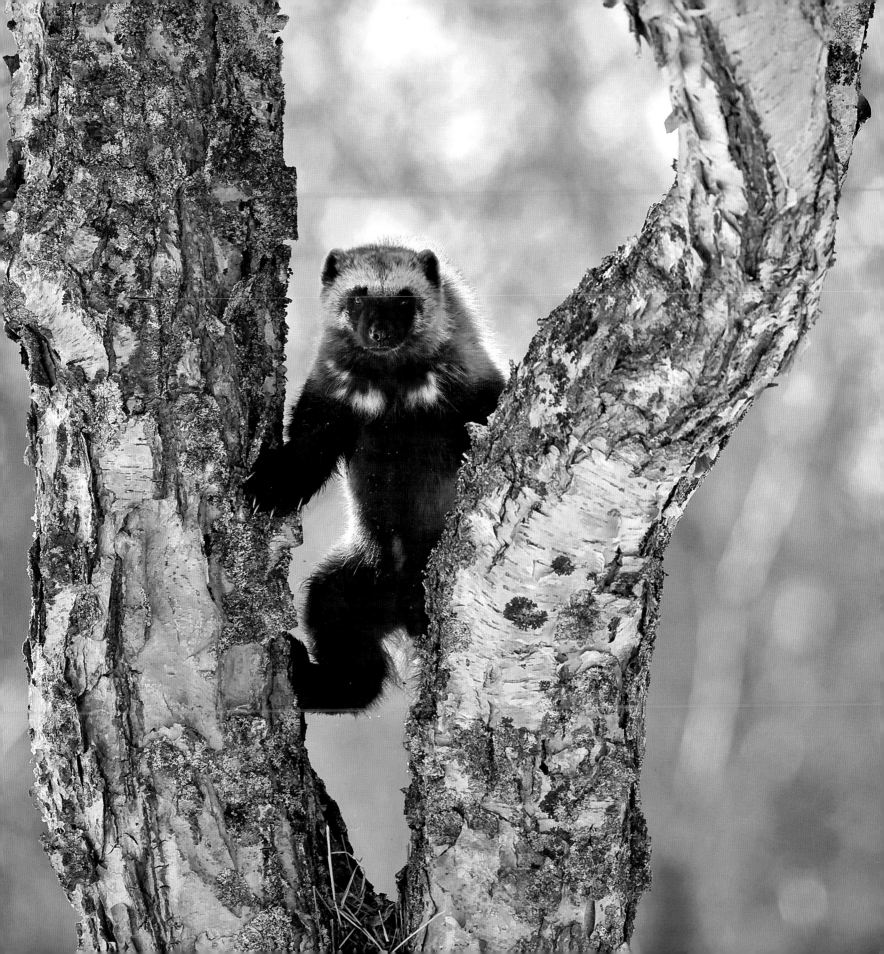

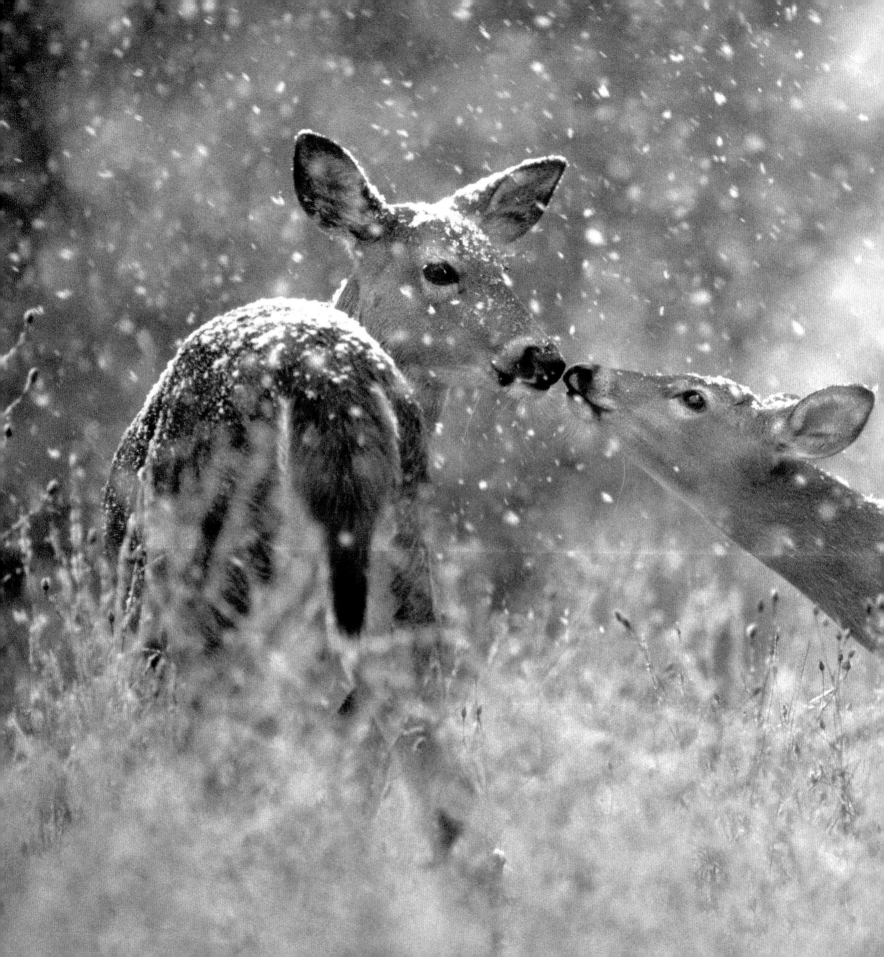

THE TOUCHING MOMENT

Carl R Sams II

In a forest glade in northern Michigan, a five-month-old white-tailed deer fawn seeks reassurance from its mother as it experiences its first snow. It's a portrait of an association that will last through until at least the summer, if both of them survive the winter, and probably for several more years if the youngster is a female. It is now October, and the pair are browsing on protein-rich vegetation – especially the mother, who needs to build her strength for her next pregnancy – as well as acorns, hazelnuts and beechmast, to put on fat to help them through the winter. In Michigan, these deer are at the edge of their northern range, and for them everything changes with the first big snowfall. If the snow accumulates and persists, a mother who hasn't regained her strength and a fawn with a low-birth weight might die if they can't find shelter in conifer stands or enough food, which might have to include bark and fir needles if the snow is too deep to be scraped away. Also, the white-tailed deer is the Michigan state game animal, which indicates another trial – hunting, the season for which extends to the end of December. The argument is that, since their natural predators, chiefly wolves, have been all but hunted out (with no more than 600–700 in the whole state), deer numbers – at more than 1.5 million – need to be controlled to prevent overgrazing and crop damage. But now another factor has entered the frame: spongiform encephalopathy, a fatal chronic wasting disease (humans can be infected, too) that is forecast to cause a 10 per cent annual decline in deer. One means of transmission can be nose to nose.

HOMAGE TO STILTS
Yossi Eshbol

Of all the subjects he has studied over more than 30 years, the photographer's favourite is the black-winged stilt, partly because of its elegance and partly its fidelity and care of its young. And of all the portraits he has taken, this is his favourite – because of both the tenderness of the interaction and the conservation success the picture has brought about. It's a sunset scene on the salt ponds of Atlit, on the northern coast of Israel. It shows a mother rising on her pink stilt-like legs to let her two day-old chicks snuggle under her to settle down for the night alongside an egg she is still incubating. The chicks were able to walk as soon as they hatched and had been hunting in the shallow water for tiny crabs and insects until they were called back for the night. Part of the beauty of the picture is the nature of the nest, which has been built from salt crystals. The dedicated parents had chosen the location not just because the water was shallow enough for the youngsters – also with exceptionally long legs – to feed in but also because the site had good all-round visibility, allowing the parents to keep watch for jackals, foxes or mongooses. But that wasn't enough to protect the chicks. Black-winged stilts can't fly until they are four weeks old, and if their parents give a warning cry, their only defence is to freeze. In fact, these chicks – like the chicks from most of the stilt and tern nests in the colony – were eaten by predators. The site was also repeatedly flooded. When the picture was awarded in the 2010 Wildlife Photographer of the Year competition, the photographer was determined to put it to use. He presented a copy to the manager of the Salt of the Earth company, which owned the salt flats, and told him the story. The result has been that the company has fenced off the area, built two islands above flood level, and now features on its salt products pictures of the birds that breed there. So, by helping to conserve its subject, the portrait has effectively become a double prize-winner.

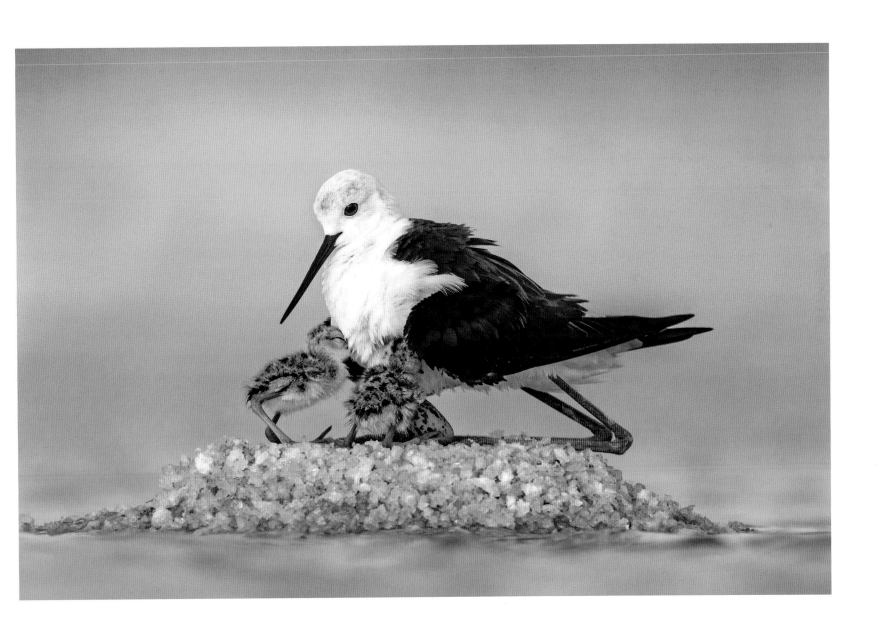

LAKE SALVADOR'S DALI

Charlie Hamilton James

A young giant otter periscopes out of the water to see over the edge of the boat where the photographer is lying. They have met before. Dali, so named by the photographer, is instantly recognizable by his throat pattern. He was the smallest of his litter, born into an extended family holding a territory in Cocha Salvador, an oxbow lake – a cut-off bend of the Manu River in the protected area of Peru's Manu National Park. This portrait shows Dali at four months old, not quite weaned and still learning to fish, dependent on his parents and their helpers (aunts and uncles and older siblings) for a share of the fish they catch and for fishing lessons. As important, he depends on group surveillance to watch for danger – in particular, for the black caiman which they share the lake with. The arrival of a boat will usually cause concern and stress, but here the otters have been studied for many years and are used to boats. Hugely social, and as individual and characterful as any human family, giant otters are very affectionate and fiercely protective of each other. And they are caring to the extent that older youngsters will stay with their family to babysit and teach the next litter – Dali stayed until he was more than two years old, and his father had remained with his own parents until he was at least three. They will even feed an ailing adult, as was the case with Dali's grandmother, when at 13 she started to lose her eyesight. One theory for the development of such a caring extended family is the need to keep watch for caiman, which not only eat the same fish as the otters but also otter pups. The real danger, though, comes from humans. Hunted for their pelts until their near extinction put an end to the trade, giant otters are endangered throughout their South American range. Today, they are still affected by human activity such as deforestation, the building of hydroelectric dams and the leaching of mercury from illegal gold mines, which poisons the fish they eat and ultimately the otters themselves.

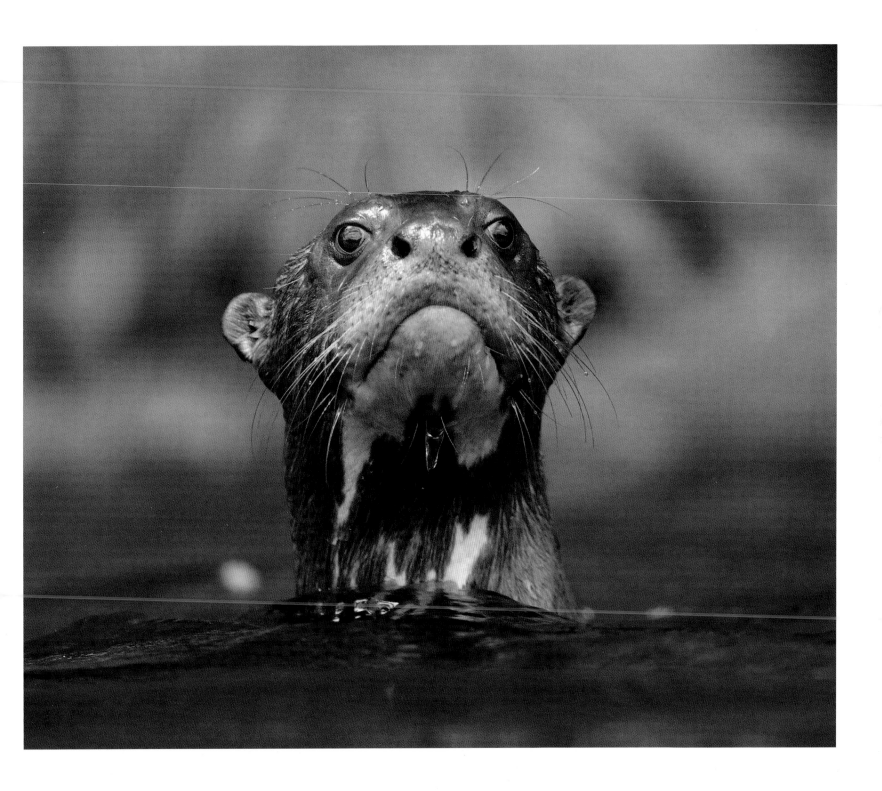

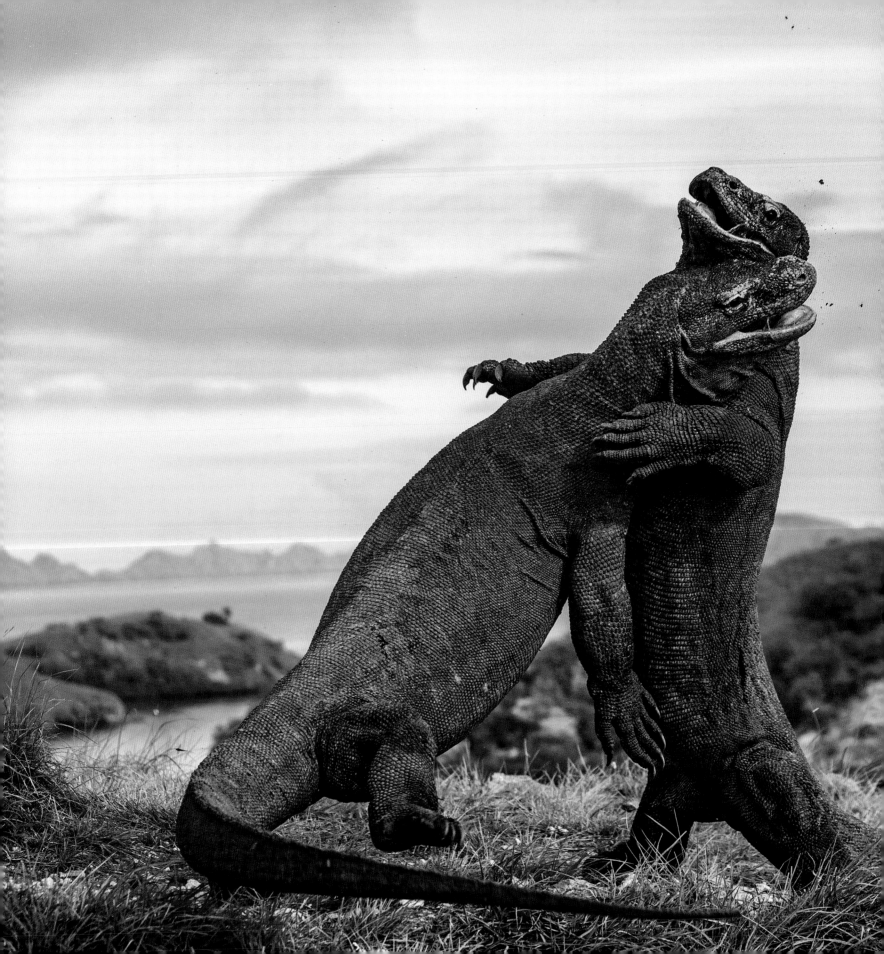

KOMODO JUDO

Andrey Gudkov

Like protagonists in a dinosaur movie, two huge Komodo dragons crash against each other in a portrait of primordial power. The setting is the island of Rinca, one of four volcanic islands in Indonesia's Komodo National Park, which along with the island of Flores, is the only place where the dragons are found. In the initial bout these two reared up on their powerful back legs and wrestled, each trying to topple the other until both fell to the ground. After a brief pause, hissing loudly, they reared up again. But a body blow from one (left) threw the other off balance, toppling him over backwards, and in seconds it was over. Both then walked off in different directions. Conducted outside the breeding season, this was a fight establishing dominance in a location where their ranges overlapped and where they may even end up feeding together from the same carcass. The power of the huge tail, capable of thrashing blows, can clearly be seen, as can the expandable throat and wide mouth, designed for large chunks of meat. But the real power lies with venom glands in the head, which channel toxins to between the sharp teeth, toxins that lower blood pressure and prevent blood from clotting. So when a dragon bites its prey, which can be as large as a deer, the animal either dies from shock or bleeds to death. It is then butchered by a hold-and-pull technique, using the strong neck muscles and a rocking motion to rip off chunks. These giant lizards – the world's largest, and in this case 2.5 metres (8 feet) long – have no fear of humans, but humans on the islands have a healthy respect for their venomous carnivorous neighbours.

SNAPPER SHOT

Alexander Mustard

Do fish have expressions? If some do, they are probably too subtle for humans to interpret. But there is no doubt that this Bohar snapper (the Arabic name for the two-spot red snapper) is scrutinizing the photographer. Its portrait could even be said to have menacing intent, at least if it had been eyeing up a meal. And that's the character the photographer wanted to portray, deliberately photographing the pack head-on. Bohar snappers are among the larger predators in the Red Sea (these individuals are each the length of a man's arm), usually encountered patrolling coral outcrops as they hunt for fish, dispatched with a mouthful of sharp teeth. But they are solitary hunters, and though pictured here as a fearsome hunting pack, these Bohar snappers have gathered not for food but for sex. For those mature enough to mate (ones older than eight or nine), the cue to gather would have probably been the pull of a nearly full moon, which will produce a strong-enough current to waft away fertilized eggs. The attention of the males will be on chasing the females when they swim up towards the surface to release their eggs, though it may be that these long-lived fish also engage in courtship behaviour or displays between rivals that divers have yet to witness. In a matter of a few days, the hundreds, possibly thousands, of snappers that have gathered over the reef will spawn en masse, creating an enormous cloud of sperm and eggs. Though other predators may feast on the nutritious soup, the sheer volume of fertilized eggs means that most will escape and get sucked away in the current to hatch into a new generation of little snappers.

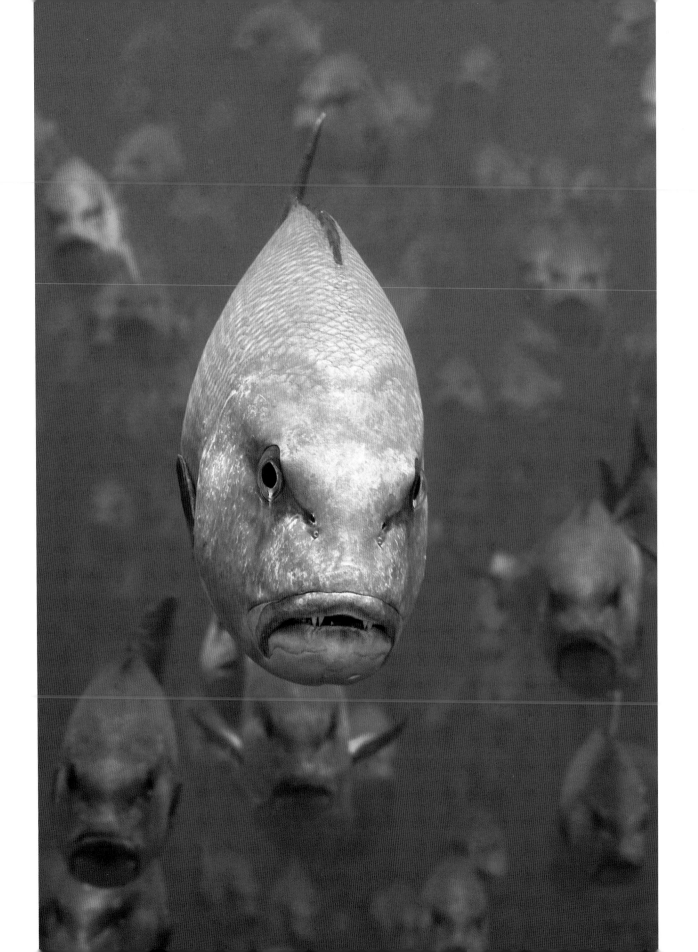

CLOSE ENCOUNTER

Tony Wu

This is a portrait of Scar, an unusually friendly sperm whale. His forehead appears enormous and is. A sperm whale's head, at nearly a third of its body length, contains both the world's largest brain and the spermaceti organ, a huge waxy-liquid-filled cavity that could function either as a buoyancy-control device for deep dives in search of squid and fish or as part of its sonar-like echolocation system – or both. When this portrait was taken, Scar was still a teenager – less than 15 years old – and little more than half his potential size of more than 18 metres (59 feet) long. He also appears large because he is close to the photographer, having charged up to him, wanting to be rubbed. Scar has always been friendly. He was born off Dominica in the Caribbean into a family group that has been studied by whale researchers since 2005. It was after an attack by pilot whales that he first approached a boat, perhaps seeking comfort, having been gashed on his head and dorsal fin, the scars from which would give him his name. He seemed to enjoy the contact with the couple sailing the boat, developing such a trust of humans that he would approach divers, inviting contact. Scar left his natal unit not long after this picture was taken in 2010, and he will probably not be seen at the breeding grounds until he is in his late 20s. But like elephants, sperm whales form lifelong relationships, and they communicate in their clan dialects over great distances. Indeed, they live in a world of sound communication. And given that sperm whales are now seldom hunted, Scar may well be living in this world when he is 80 or 100 years old.

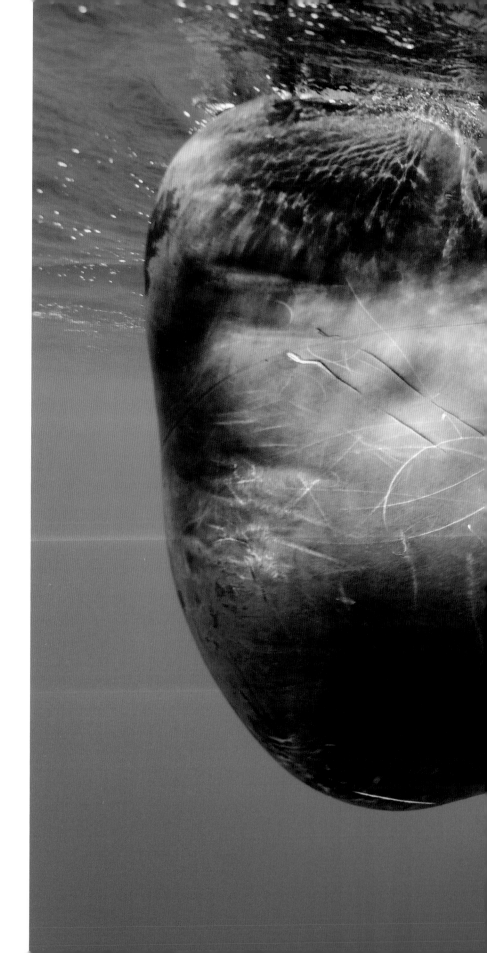

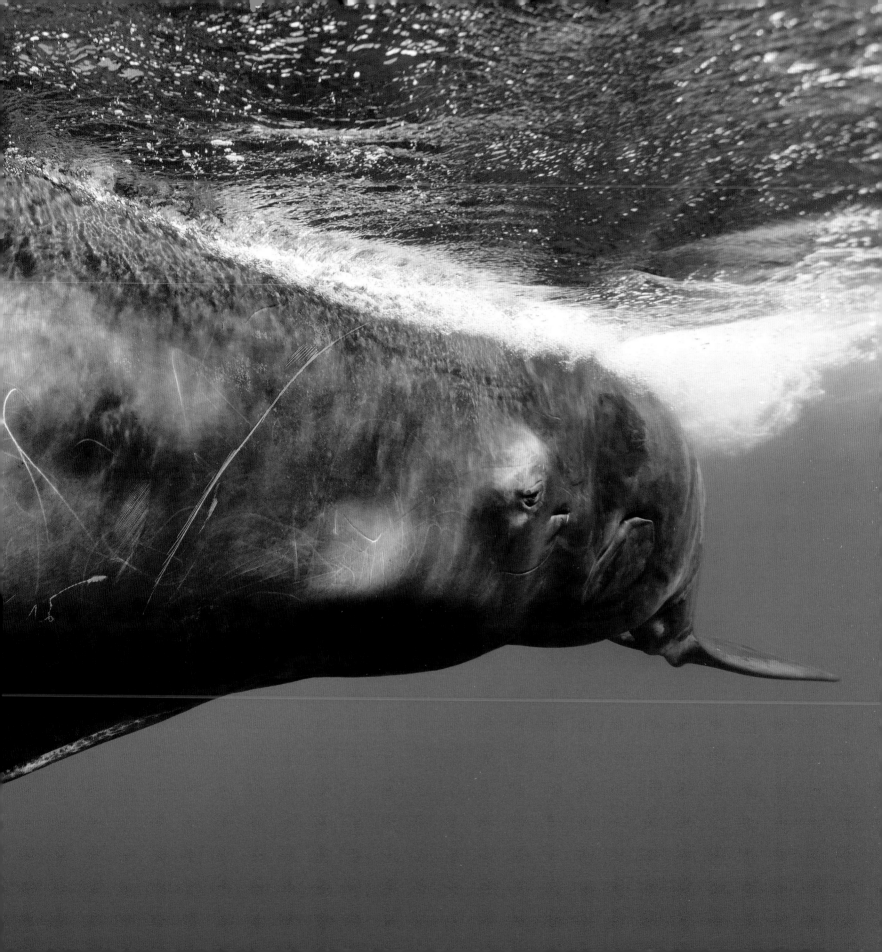

LOOKING FOR LOVE

Tony Wu

He's big, he's impressive and he's poised to see off any male that dares challenge him. At nearly a metre (3 feet) long, with a massive dome and sporting pastel-pale breeding colours that almost glow in the dark, this Asian sheepshead wrasse poses perfectly for his portrait. To the potential mates that visit his territory, he appears irresistibly impressive. Only potential rivals close to his size will attempt to challenge him for the right to mate with his harem, as his teeth – capable of crushing shellfish and crustaceans – can tear chunks out of them. The location of his domain is an ideal spawning site with strong currents in a protected area off a Japanese island where sheepshead wrasse have not been overfished. But these wrasse are also found in the South China Sea and elsewhere in the western Pacific. When pumped up with hormones, this dominant male's passion is unbounded, and over several weeks, when conditions are right for spawning, he will mate with females many times a day and charge any intruder. What is surprising is that he was once a female and that, when he was young, he looked like another species altogether, being bright yellowish-orange with a white stripe from eye to tail. Then as she grew and matured, perhaps at three years old, possibly later, she sported pale earthy colours. Then when much older, having reached a large size, something triggered a sex change. Possibly it was a preponderance of females, few males or perhaps the weakening or the death of a male territory holder. No one knows for certain as there have been no long-term studies. But one thing for sure is that a big male, who may live to be 30 years or older, has the best of both worlds. Having reproduced as a female, he is now multiplying his chances of spreading his genes by monopolizing a harem.

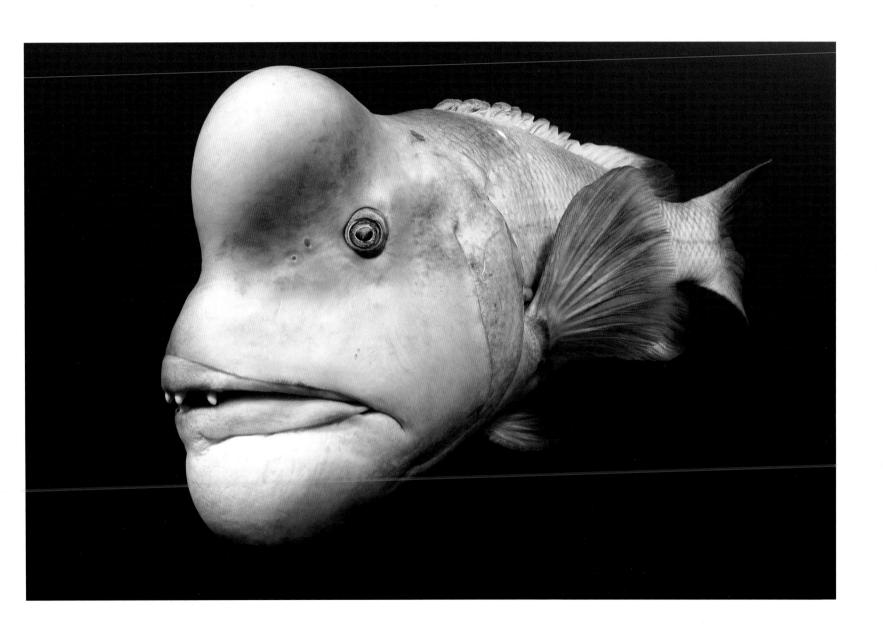

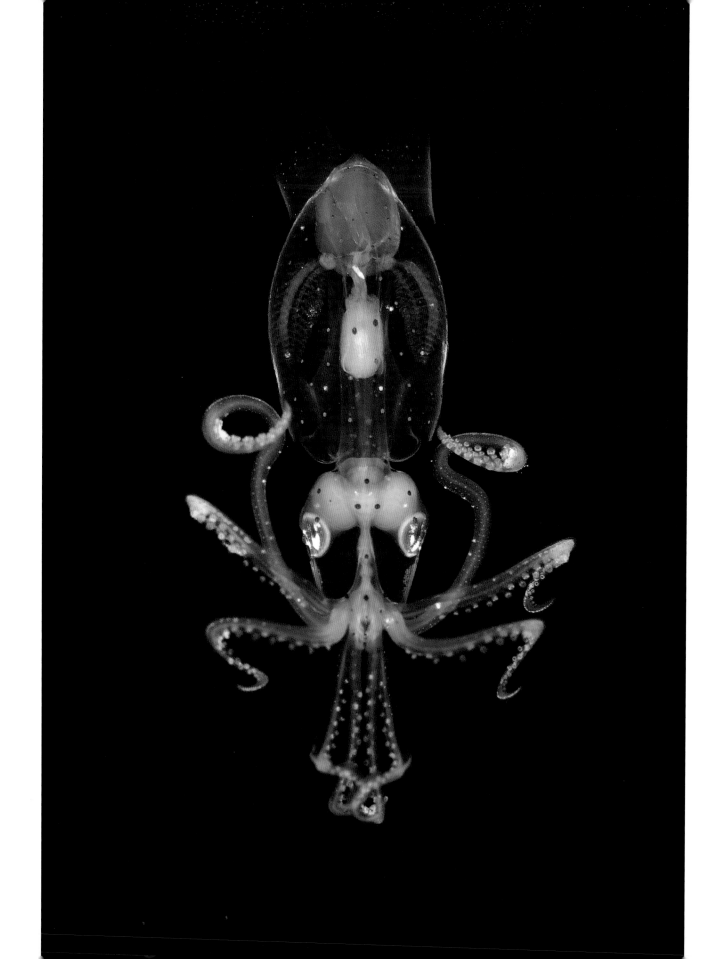

SQUIDLET

Fabien Michenet

Not much bigger than a thumbnail, this juvenile sharpear enope squid is portrayed in its nocturnal hunting position, head down, hanging in mid-water in the ocean off Tahiti. Its tentacles are folded, ready to spring out and grab prey – planktonic animals even smaller than itself, such as tiny shrimps, which under cover of darkness rise up to the surface to feed. Being transparent, it would be almost invisible to its prey. But here it has been illuminated by a minuscule of flash. The light has revealed its internal organs, including the gills towards the rear of its body, and the polka-dot pigmented spots, photophores, that cover its body. Glowing in the dark are also light-producing organs below its eyes that use bioluminescence to either attract prey or confuse predators, depending on whether the squid is hunting or hiding. At daybreak, it will swim back down to where the only light is bioluminescence – its own and from other deep-sea animals. When a sharpear enope squid reaches adulthood – at 15–45 centimetres (6–18 inches) long, females being much larger than males – it will hunt near the sea bottom. But growing up also marks the end, because at not much more than two years old, when it finds a member of the opposite sex and spawns, the squid will die.

SQUIRREL IN REFLECTION
Kai Fagerström

A quick glance towards the camera, and the red squirrel's portrait is caught, reflected in an old window pane as a dusty silhouette. The location is a deserted cottage in a forest in southwest Finland. Some 40 or so years before, a family of 13 people inhabited the cottage. Now animals have moved in. The squirrel has the run of the house, though its night-nest is up in the attic. Spotting the old window pane (with dust marks made by one of the badgers that live under the kitchen), the photographer knew exactly the portrait he wanted. 'The squirrel got nuts and I got the portrait,' he says. Photographing through the window, using just natural light, it did take many days for the light and the squirrel to come together in just the right way. But 'this was fine with me,' he says. 'The journey is more important than the destination.'

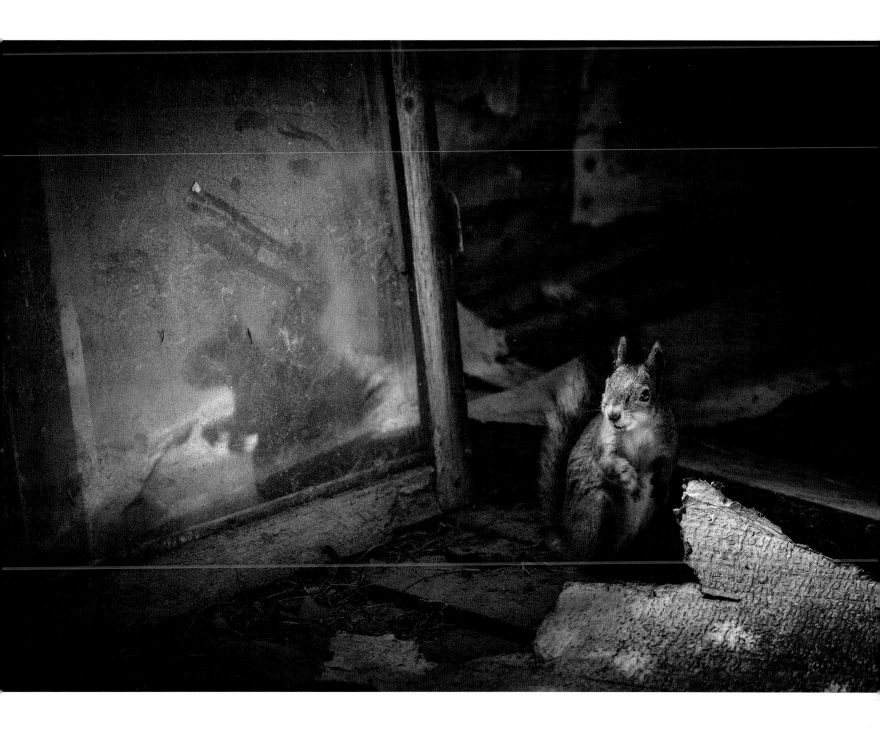

THE MOUSE, THE MOON AND THE MOSQUITO
Alexander Badyaev

Such a portrait of a wild deer mouse could be made only through perceptive observation, astute curiosity and perfect timing. The global pedestal is an inflated giant puffball that appeared in the territory of a variety of rodents, including chipmunks and squirrels as well as nocturnal deer mice. The photographer noticed the growing fungus on his daily walk along a trail leading down from his cabin in the Blackfoot Valley in western Montana. Looking at it closely, he began to see more and more little marks suggesting that various animals were climbing on and probably scent-marking the novel white ball. Observing that, as the puffball rose, the moon was enlarging, the idea for a picture began to take form. On the evening of the full moon, he set up his camera and waited for the social-centre activity to begin. The visitors were deer mice, which scampered across the puffball, chasing each other and pausing only for the briefest of moments. What the photographer also had to wait for was the rising moon, which needed to be high and bright enough to backlight the scene. When one mouse paused long enough to investigate a persistent mosquito, a gentle pulse of flash froze the action and completed the fairy-tale setting.

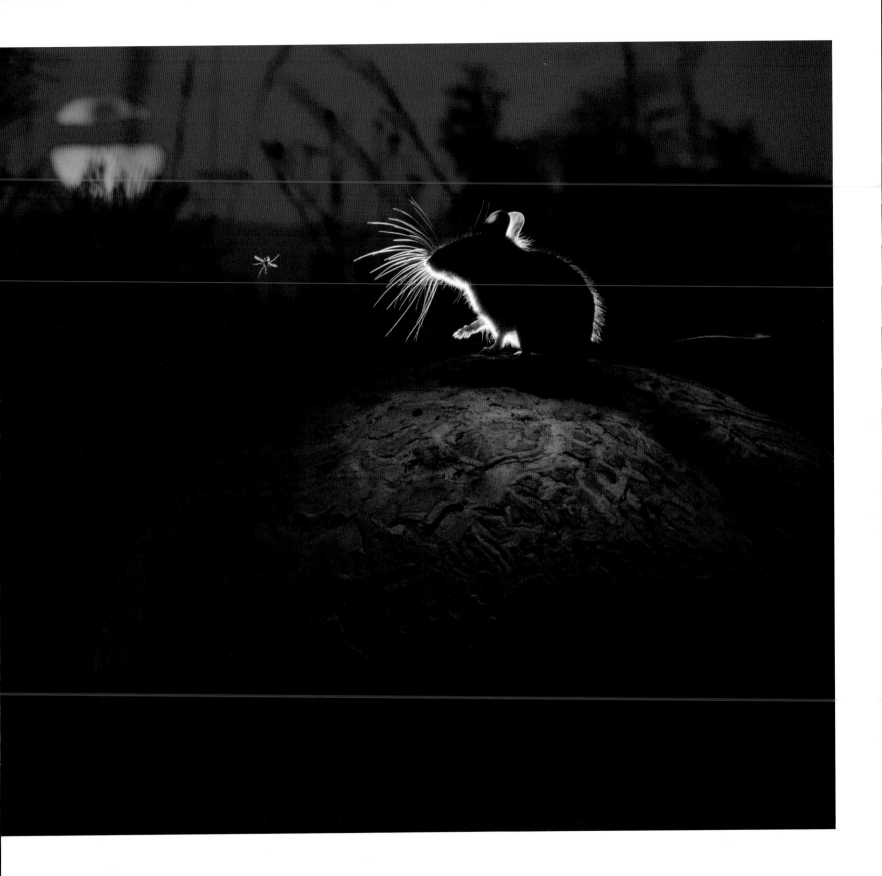

ANT ON A PETAL
András Mészáros

Ants are among the most ubiquitous of creatures, numbering millions of billions, but it is only by pausing to consider them close-up that they are revealed as individuals. Here, using two sets of extension tubes and a teleconverter, the photographer focuses in on a red ant, portraying her on a refreshment break. The raindrop is on the petal of a mallow flower in a woodland glade in Hungary, and the ant has been on the flower stem guarding aphids that are busy sucking sap. The aphids are tended like a herd of cows, milked for the sugary liquid that they excrete from their rear ends. This excess sap is sucked up by the workers and stored in their crops to carry back to the colony nest, where it is regurgitated to feed their sisters and the grubs. Water and nectar will be carried back in the same way – ants, in fact, live on a liquid diet. Though red ants hunt invertebrates as well as scavenge, cutting up or chewing food with their mandibles, they can't swallow the pieces and instead suck up the contents. This is because, like all ants, the waist between their thorax and abdomen is so narrow that only fluid can pass through it. But the advantage of a narrow waist is that it provides flexibility to a creature with an external skeleton – an armour of chitin – allowing an ant to bend its abdomen in under its body to inject or spray venom. In fact, red ants are renowned for being aggressive, stinging anything that threatens the colony and stinging or biting any insects that look as if they might be a danger to their sap-sucking aphid herds.

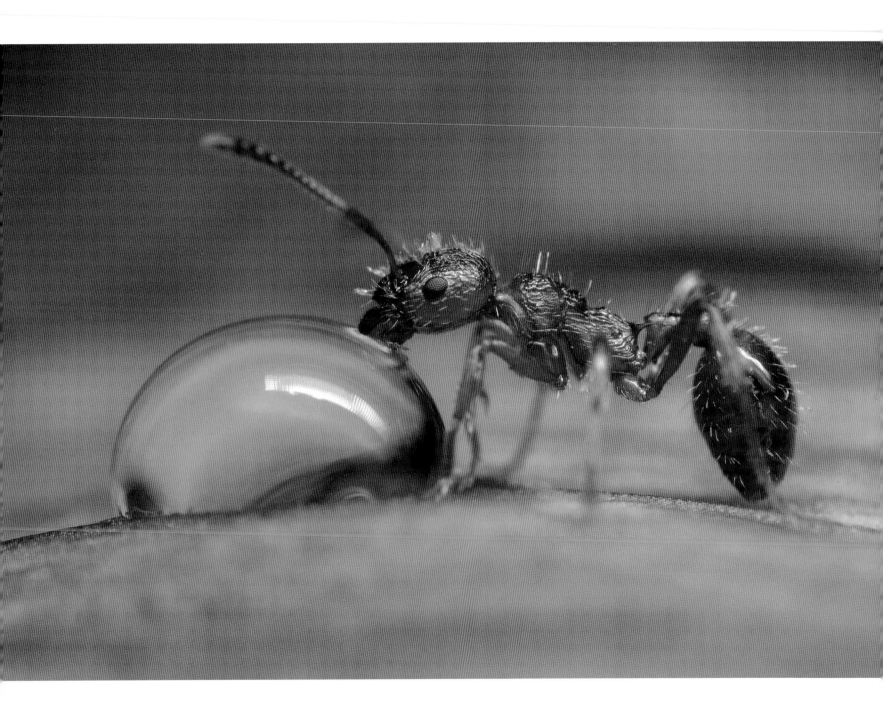

A VERY SENSITIVE BEAST
Larry Lynch

It was big, very big, and very full. Judging by its size – more than 3 metres (10 feet) – this American alligator was a male. It had been gorging on fish trapped in pools as the river, in Florida's Myakka River State Park, dried up. Knowing that the giant was satiated and not about to move, the photographer set up his tripod at a respectful distance and waited until dusk. Using flash at the lowest setting, he focused on the reptile's eyes – the defining touch to a portrait of a nocturnal hunter. Alligators are opportunistic freshwater predators. Their main prey is fish, along with turtles, snakes and small mammals, and they tend to hunt mostly at night, especially in the heat of summer. That their eyes shine red is the result of light bouncing off the tapetum – a reflector system at the back of the eye – and back through the eye's photo-receptor layer, enhancing the alligator's ability to see in dim light. The tapetum also adapts to the amount of light, depending on the time of day. That an alligator can find its way around in the dark and under water is partly due to another adaptation: multi-sensory organs on the skin of its head and especially around the eyes and jaws, which give it a pressure sensitivity more acute than that of human fingertips. This allows it to sense pressure waves caused by the smallest water movements and to help it detect prey in the dark. The ones around the mouth and teeth are also presumed to help it identify prey. Despite its thick armour of scales and its sluggish looks, it therefore appears that southeastern USA's biggest land predator is, when it comes to vision and touch, a very sensitive beast.

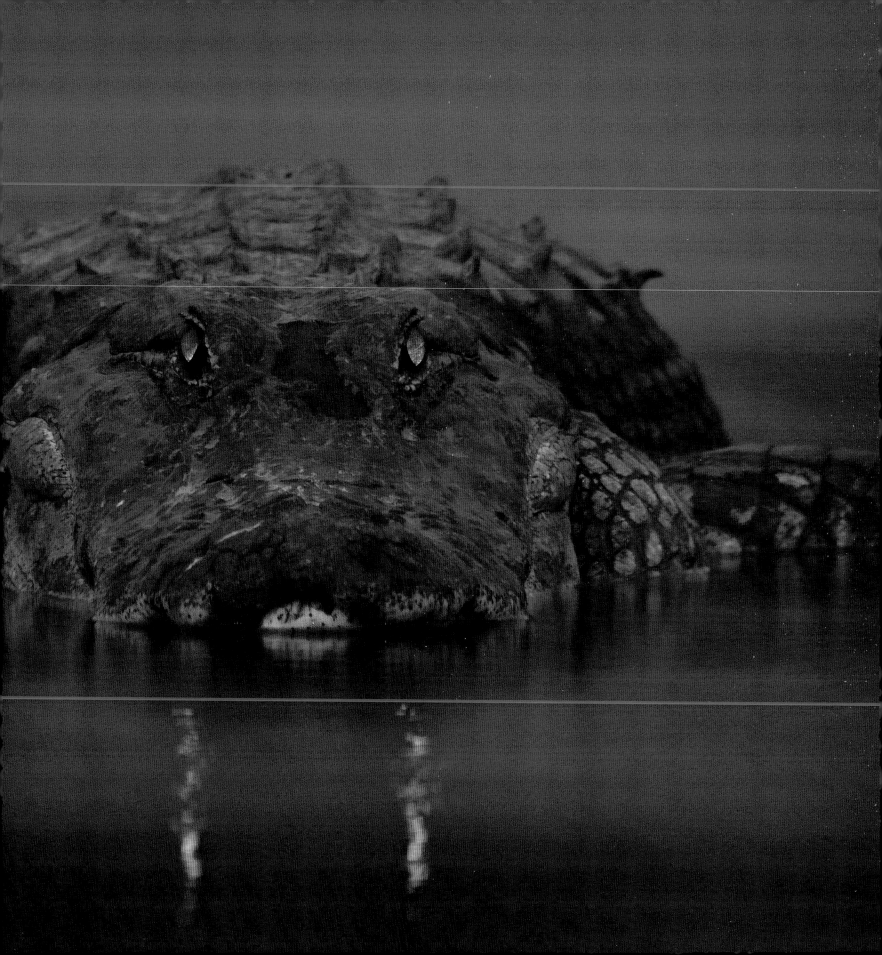

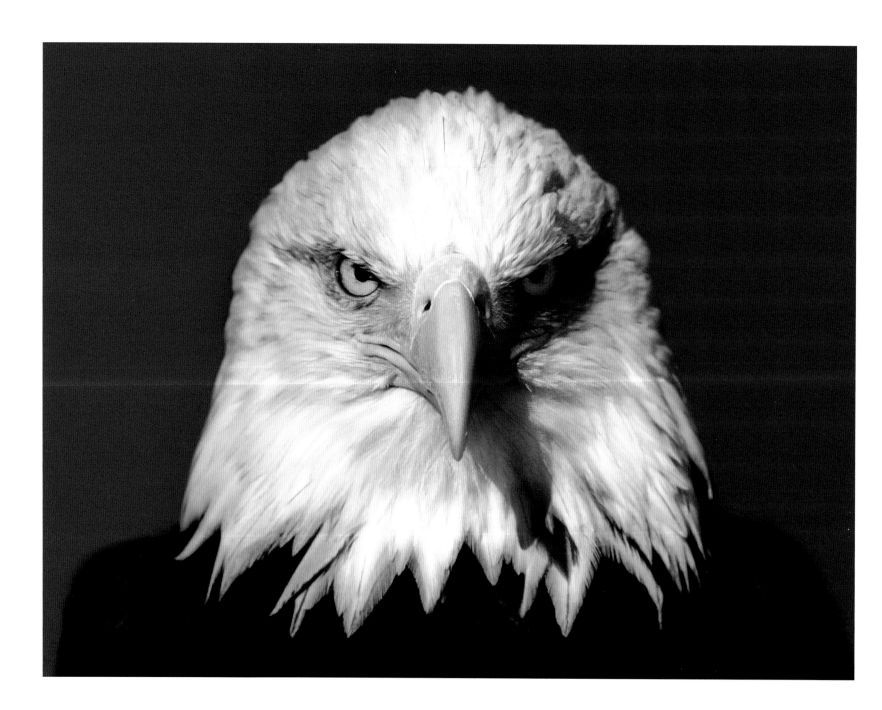

PORTRAIT OF THE TIMES
Wendy Shattil and Bob Rozinski

You couldn't get a more iconic portrait of the national bird of the United States of America – an unforgettable eye-level image set against a blue background, hinting at the blue of the US flag. Eagles have through history been seen as symbols of power, and so it is not surprising that the bald eagle, native to North America, was chosen in 1782 as the image for the 'great seal' of the newly independent American nation. Neither is it surprising that Donald Trump's presidential campaign chose this photograph of a bald eagle to project Trump's 'direct and unflinching persona' to the American public and to raise funds. The problem was that the image was used by the campaign without the permission of the photographers, resulting in an infringement-of-copyright lawsuit, settled out of court. In fact, the bald eagle is not as its image suggests a proud top-of-the-league hunter. It prefers to save energy by scavenging and will steal fish kills more often than make them. This is what prompted Benjamin Franklin to describe the species as 'a Bird of bad moral Character' which 'does not get his Living honestly'. But, of course, even if its behaviour can at times be seen as bullying, the bald eagle is merely an opportunist – a valid means of survival, especially in winter in the frozen north. When this picture was taken, in 1980, the species was endangered, having been decimated by sport hunting, persecution and the past use of the pesticide DDT. But since 2007, it has been off the endangered list and is doing well, except for a problem of lead poisoning in regions where it feeds on the offal from game shoots. Having no regard for national boundaries or its national status, the species is also flourishing in Canada, and some pairs even breed in Mexico.

DEATH MASK

Franco Banfi

Such a terrifying face appears like a warning from the deep, but in fact it is a face that's designed never to be seen other than at the moment its owner bursts out of the grit to grab an animal passing overhead. As a nocturnal ambush predator (here made visible by strobe light), the marbled stargazer buries itself in the sandy substrate of the seabed, remaining under cover and unmoving. It exposes only enough of its head to enable it to see as well as 'breathe' (unlike other fish, it 'breathes' by taking in water through its nostrils rather than its mouth for filtering through the gills). Though its head is big relative to its body, the whole fish is a mere 20–22 centimetres (8–9 inches) long, with a recognizably fish-shaped body. The individual portrayed here was on the sea floor in relatively shallow water in the Lembeh Strait off the Indonesian island of Sulawesi, where the current is gentle and there is plenty of passing prey. In the dark, a marbled stargazer probably senses the approach of prey through the bow wave a fish makes. Then, as the fish moves overhead, the stargazer lunges forward at speed (bending its spine to generate the force) and grabs it with a mouth capable of encompassing an animal up to almost half its own body length. It digests at leisure, producing copious amounts of bile to help with the job. In its semi-buried position, it lies relatively safe as, in addition to an extra thick skull, it can erect two venomous spines and can surprise even the biggest of potential predators by giving it an electric shock.

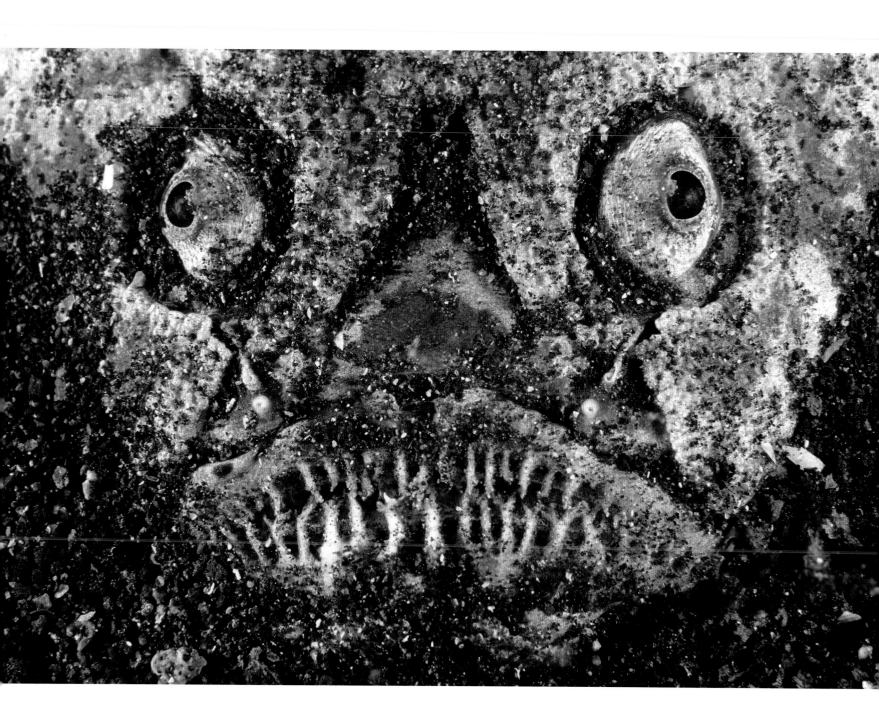

TROUBLEMAKER
Stefano Unterthiner

This is a monkey with character – and not just because
of the punk haircut and amber eyes so characteristic
of Sulawesi crested black macaques. It's also their
expressive faces and curiosity. Nicknamed Troublemaker
by field researchers, this young male had been part
of a group foraging on the volcanic rocks of a beach
on the edge of Sulawesi's Tangkoko Nature Reserve –
the macaques' forest stronghold on the Indonesian
island. But Troublemaker was far more interested in
Stefano and his camera than in beachcombing. In fact,
Troublemaker was a challenge. Here he is staring at
his reflection in the lens and considering what to do
about it. Sulawesi crested black macaques live in
big, hierarchical social networks, and young males
always have an eye on their place in society. Like other
primates, they also have recognizable personalities, and
personality can affect social ranking. Troublemaker may
have been destined for a high social position, but in
another sense his future was precarious. The Sulawesi
species is listed as critically endangered, and in the past
30 years, numbers have fallen by 90 per cent. Today
there are fewer than 1,800 in the reserve. Continued
forest loss is a major reason, but hunting also plays
a part. Mischievous individuals are more likely to get
caught in traps or killed when crop-raiding, and now
Troublemaker himself has disappeared, presumed killed.
Perhaps, though, the future for crested black macaques
lies in their characterful nature, and the realization
by more Sulawesians that these iconic monkeys are a
heritage to be proud of and have greater value as draws
for ecotourism than as butchers' meat.

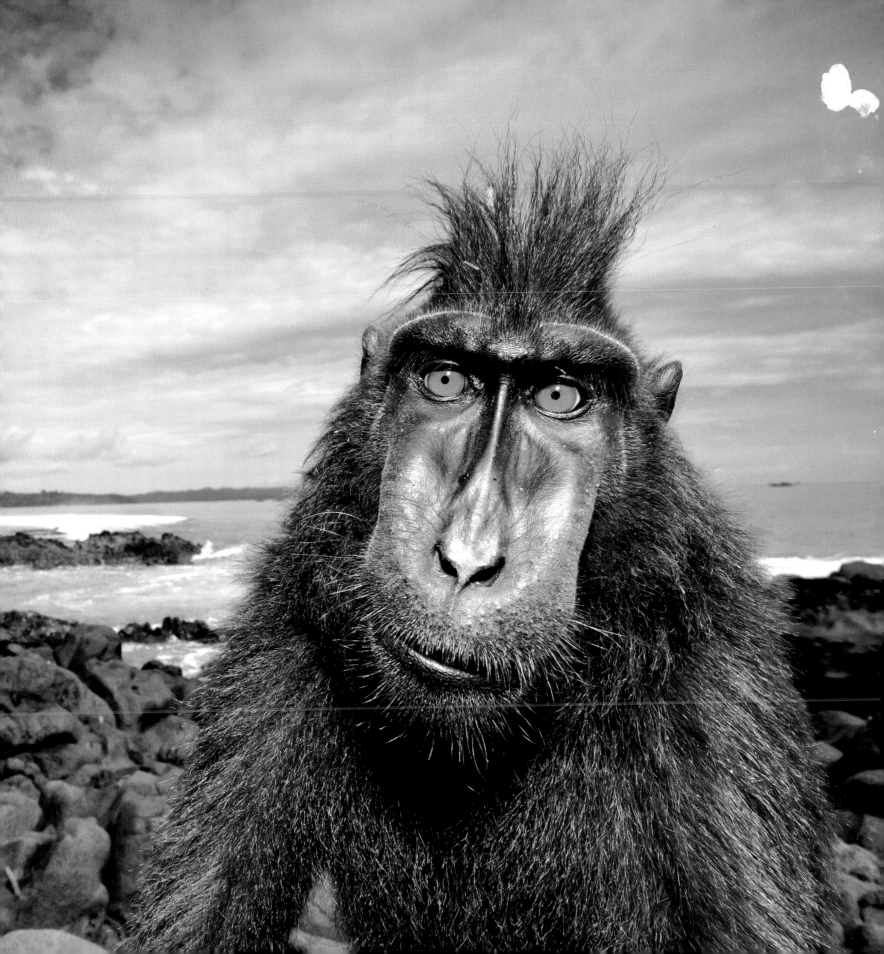

THE ART OF RELAXATION
Jasper Doest

Though just a portion of the face is revealed and the subject's eyes are closed,
this is a portrait which encapsulates pure relaxation. That we can interpret this is
because the subject is a fellow primate, and we are attuned to the tiniest signals in
a face so similar to our own. Indeed, the eyes rolled back under the translucent lids
suggests a state of dreaming. The dozing individual is a young Japanese macaque,
once considered by the Japanese as a sacred mediator between humans and the
gods. Today it is a protected species, though its fate is mixed. In some places it
is indulged, but elsewhere it is persecuted as a pest. Here the youngster is with
its large extended family group, soaking and socializing in a hot-spring pool – the
famous Jigokudani monkey 'hot tub' in the volcanic mountains of Joshin'etsu-kogen
National Park, on the main island of Honshu. The local Japanese macaques have
been coming here to relax and warm up every winter since the 1960s, when a bold
female, presumably having observed the pleasure exhibited by humans bathing
in the pool, took advantage of the hot spring, and then brought her relatives.
Today the pool is kept just for the macaques, and in winter, a stream of them come
to warm up, observed and photographed by a gaggle of human onlookers. Now
that the owners of the site put out food for them, the macaques come all year.
But on this occasion, it was winter. There had been a blizzard earlier, and the snow
that had gathered on the youngster's thick winter fur had melted into water drops.
Showing no fear of the nearby human presence, it had fallen asleep in front of
the photographer, accompanied in the pool by 25 or more sleeping adults –
a scene of pure tranquillity.

THE ANGRY QUEEN

Piotr Naskrecki

This is the face of an irate armoured black ant.
Encountered among the leaf-litter on the forest floor in
Cambodia, she has had a plastic diffusion box placed
around her so her portrait could be taken without the light
glinting off her armour. That she was a queen was obvious
by her size – at 3 centimetres long (just over an inch), she
is much larger than the worker caste of her species. Parts
of her body also reveal a design for flight: an additional set
of eyes – three simple ones on top of her head (just one is
visible here) – sensitive to polarized light and believed to
be used for aerial navigation, plus the attachment points
on her sides where the wings used for her nuptial flight
had been. Growing up fertile (unlike the worker females),
she would have flown from the nest when conditions were
right, remained airborne until mated by winged males from
other colonies and then come down to the forest floor,
shedding her wings. She would then have looked for a
place to build a colony nest out of leaves and detritus,
possibly in a tree. Maybe she was on her way to do that
when the photographer encountered her, or maybe she
had started a nest, laid her first eggs and was now foraging
for her newly hatched brood – which would rear the next
brood of workers. To defend herself when out foraging,
her armour includes a curved hook on either side of her
thorax (hidden here by her antennae), capable of slicing
through skin, and three equally viscous-looking curved
spines on her 'back' (here arched up in defensive mode).
Other weapons include strong, five-pronged jaws (the
mandibles) and the ability to spray a jet of formic acid
from her abdomen – here curved round ready to fire if
provoked. She is indeed a queen not to be crossed.

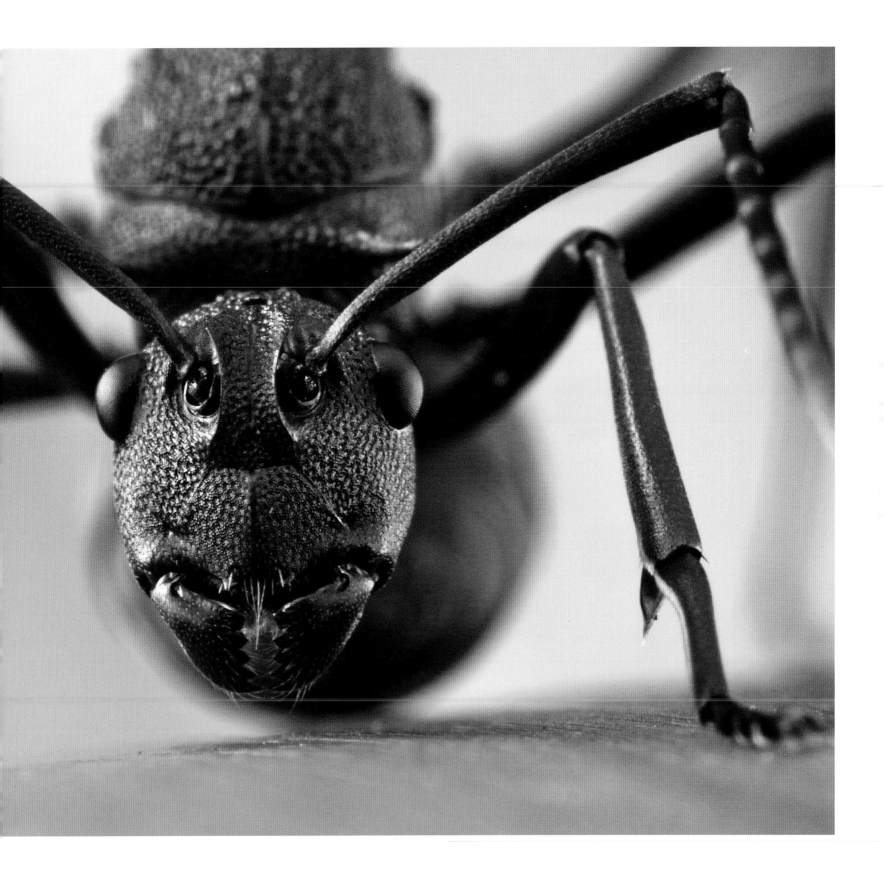

LITTLE BIG-HEAD
Javier Aznar González de Rueda

Treehoppers are tiny, and this Amazonian one is no exception. But what focuses
attention in such a full-frontal portrait is its relatively gigantic helmet. Like all
sap-sucking bugs, this *Bocydium* species of treehopper has a straw-like mouthpart
that can pierce tough plant stems, bypassing any of the plant's chemical defences
by going straight for the nutritious sap. But having to feed stuck into a plant makes
it vulnerable to predators such as wasps and birds. All treehoppers have a plate-like
structure growing from the thorax – the area between the head and the abdomen –
referred to as the helmet. This is often expanded into strange and wonderful shapes,
colours and textures that seem to hide or protect the bodies of treehoppers from
predators. Sometimes the helmet camouflages the bug as a leaf, debris or even
a bird dropping, or it is moulded into thorns, spikes or spines. In some species,
it morphs into an ant, which appears to straddle the treehopper, or it transforms
the bug into a wasp. But in the case of *Bocydium*, the function of such a helmet is
a mystery. Both sexes have it – the hollow balls, together with a long spike extending
back over the body, also covered in hairs. Could the balls resemble the eyes of some
predatory insect or spider? Could the comparatively light and hollow headgear be a
decoy to deflect a peck, allowing *Bocydium* to hop away? But then what are all the
hairs for? The species is solitary and, like all treehoppers, communicates through
vibrations. So could the air-filled ornamentations help amplify communication?
Possibly not. But as no one has studied this treehopper – and most other tropical
treehopper species in the wild – there is as yet no conclusive answer.

LITTLE BIG-EARS

Bruno D'Amicis

The ears say it all. Sensitive to the slightest sound, they are swivelled to face the camera. Such large ears are a desert adaptation, which radiate heat in the day and at night can pinpoint the slightest movement of desert insects – a major part of a fennec fox's diet – or other animals small enough to pounce on or dig out. But its ears can also lead to its demise. They make a cub, such as this three-month-old, irresistible to tourists, who may be tempted to buy one as a pet or pay to have their photograph taken with it. The footwear of the Tunisian boy offering the cub for sale points to another part of the story: poverty, unemployment and lack of education. For an impoverished North African, $70 for a cub is good money, and though taking a fox from the wild is illegal, there is little enforcement of the law. Had this cub not been dug out of its sand-dune den, it would have remained with its family until at least six months old and probably much longer. Fennec foxes are believed to mate for life, and older offspring may help raise the next year's litter of cubs. They are also highly social. But relatively little is known about their behaviour in the wild, as fennec foxes are incredibly difficult to study in their North African desert and semi-desert habitats. They are very wary of humans, can hear over great distances, are camouflaged by sand-coloured fur, stay in their dens during the heat of the day and hunt mainly at night. But once a den has been located, catching fennec foxes is, unfortunately, relatively easy.

STILL LIFE IN OIL
Daniel Beltrá

It's a portrait of haunting beauty, the elegant brown pelicans, frozen in poses as if on an artist's drape, in a striking composition in honey, walnut and mahogany oil paint. The reality, of course, is a ghastly mess and a stinking box into which traumatized brown pelicans drenched in oil had been placed, awaiting attempts by volunteers to clean them. It was an image that came to symbolize the worst single environmental disaster in US history, the BP Deepwater Horizon oil spill, which in April 2010 released 5 million barrels of crude oil into the Gulf of Mexico. The news coverage at the time was dramatic, but this award-winning artistic rendition of the drama has had greater lasting power. The legacy of the spill itself also goes on. It not only fouled the shorelines of five states, killed hundreds of thousands of birds and thousands of marine mammals and sea turtles but it also contaminated their habitats. Only once the legal wrangling over BP's fine was done were the scientific estimates of the toxic effects published. While just 8,500 dead and impaired birds from 93 species were collected at the time, coastal bird deaths in the acute period have been estimated at 800,000 and offshore bird deaths at 200,000. Scientists also remain worried about the long-term effects of such a major deepwater infusion of pollutants into the bay and their effect on the wider biodiversity and microbial life of an already-stressed Gulf Coast ecosystem.

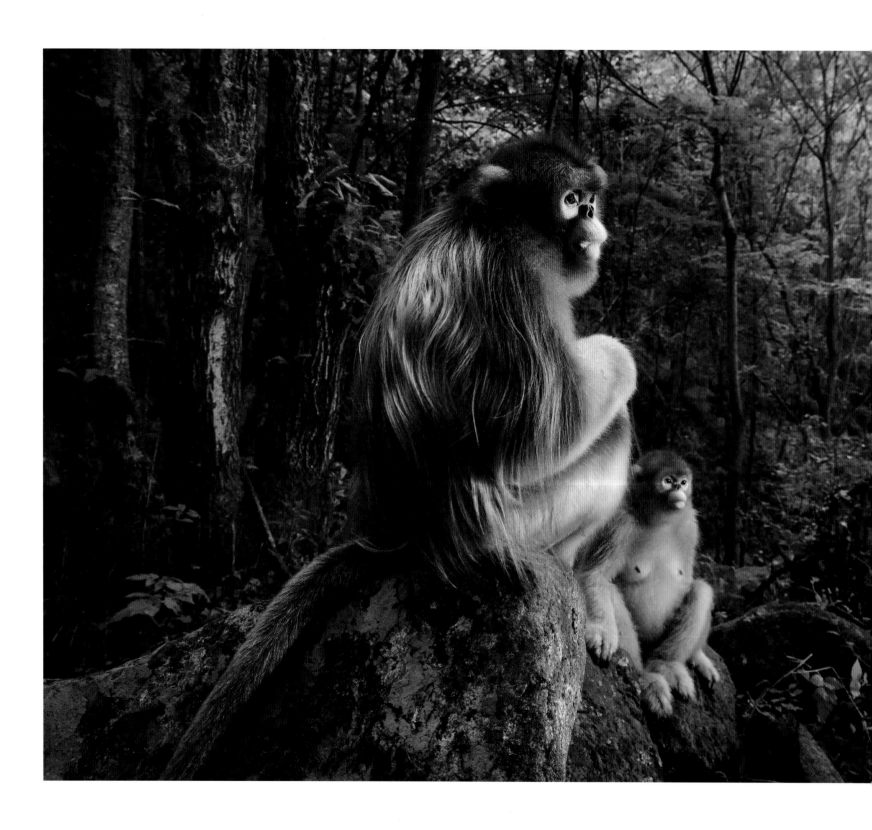

THE GOLDEN COUPLE
Marsel van Oosten

The sitters are a male and a female golden snub-nosed monkey of the Qinling race, considered by many to be the most handsome of all monkeys. The male (left) leads a small group, part of a 50-strong troop. He and the female have come down from feeding in the trees to keep watch on a squabble between bachelor males in the valley below. Seated in the perfect spot, in the perfect light, with the perfect backdrop, this was a gift of a pose. But to catch it required more than serendipity. The photographer has been to China four times to photograph them high in the Qinling Mountains, the only place where they are found, with a population of less than 4,000. That he could approach close enough to take the portrait was because the monkeys, already used to researchers studying their behaviour, became accustomed to his presence. Normally, though, the groups of monkeys would be feeding in the trees and constantly on the move, and if the photographer did catch up when any came to the ground, the light was seldom right. Also, to portray the male's full splendour – his golden cape as well as his blue face – required shooting from a certain angle. But on this spring morning, it all came together, needing just a low pulse of flash to illuminate the male's golden locks and to produce an award-winning, unforgettable portrait.

PHOTOGRAPHERS

Karl Ammann (Switzerland)
www.karlammann.com
46 Nikon F4 + 800mm lens;
Fujichrome 100.

Javier Aznar González de Rueda (Spain)
www.javieraznarphotography.com
118 Canon EOS 70D + 65mm f2.8 lens;
1/200 sec at f7.1; ISO 100;
Yongnuo + Quadralite Reporter flashes;
Sirui tripod + UniqBall head.

Alexander Badyaev (Russia/USA)
www.tenbestphotos.com
102 Canon EOS-1D Mark IV + 105mm lens;
2.5 sec at f14; ISO 250; Canon 430EX II
flash; tripod.

Franco Banfi (Switzerland)
www.banfi.ch
110 Nikon F90X + 105mm macro lens;
1/100 sec at f22; Fujichrome Velvia rated
at 40; Sea & Sea Yellow YS-300 & YS-30
strobes.

Daniel Beltrá (Spain/USA)
www.danielbeltra.com
122 Canon EOS 5D Mark II + 35mm f1.4
lens at 35mm; 1/30 sec at f4
(-0.7 e/v); ISO 800.

Mario Cea (Spain)
www.mariocea.net
70 Canon EOS 7D + 100–400mm lens
at 160mm; 1/15 sec at f7.1; ISO 250;
four Godox V860 flashes; LED light lantern;
Benro tripod + ballhead; cable release;
hide.

David Chancellor (UK)
www.davidchancellor.com
4 Mamiya 7 II + 80mm f4 lens; 2 sec
at f11; Kodak Portra 160;
Manfrotto tripod; cable release.

Jordi Chias (Spain)
www.uwaterphoto.com
68 Canon EOS 7D + Tokina 10–17mm lens
at 10mm; 1/80 sec at f11; ISO 160;
custom-made housing; two Inon flashes.
72 Canon EOS 5D + 17–40mm f4 lens;
1/80 sec at f13; ISO 200; custom-built
housing; two Inon Z-220 strobes.

Martyn Colbeck (UK)
www.martyncolbeck.com
Agent: www.gettyimages.co.uk
22 Canon EOS-1V + EF 300mm f2.8 lens;
1/15 sec at f2.8; Ilford Delta 100;
fluid-head tripod.

Mervin Coleman (USA)
www.mervcoleman.com
74 Canon EOS-A2 + EF 300mm lens +
Canon 1.4x extender at 420mm; Fujichrome
Velvia; tripod.

Bruno D'Amicis (Italy)
www.brunodamicis.com
120 Canon EOS 5D Mark II + 17–40mm f4
lens at 38mm; 1/160 sec at f4; ISO 400.

Tui De Roy (New Zealand)
www.tuideroy.com
28 Nikon F5 + 300mm lens; 1/250 sec at
f2.8–f4.5; Fujichrome Provia 100; flash +
Fresnel lens.

Jasper Doest (The Netherlands)
www.jasperdoest.com
114 Nikon D3 + 105mm f2.8 lens; 1/200
sec at f16; ISO 2000.

Thomas Dressler (Spain)
www.thomasdressler.net
34 Canon EOS 5 + 28–105mm lens; 1/125
sec at f6.7; Fujichrome Velvia 50.

Yossi Eshbol (Israel)
www.facebook.com/yossi.eshbol
86 Nikon D300 + 600mm f4 lens; 1/800 sec
at f6.3 (-1.7 e/v); ISO 200; tripod; hide.

Kai Fagerström (Finland)
www.kaifagerstrom.fi
100 Nikon D3S + 70–200mm f2.8 lens;
1/30 sec at f4; ISO 1800.

Jess Findlay (Canada)
www.jessfindlay.com
66 Canon EOS 5D Mark III + 400mm f5.6
lens + 12mm extension tube; 1/5 sec at
f16; ISO 100; Gitzo tripod + Induro ballhead.

David Gallan (Australia)
www.greybox73.wixsite.com/davidgallan
www.facebook.com/Understorey-
a-film-on-the-south-east-forest-
campaigns-940034452718427
78 Nikon D7000 + Nikon 10–24mm
f3.5–4.5 lens at 15mm; 1/100 sec at f4.5
(-0.67 e/v); ISO 3200; Sabre trigger;
home-made housing; Manfrotto tripod.

Edwin Giesbers (The Netherlands)
www.edwingiesbers.com
24 Nikon D7100 + 80–400mm f4.5–5.6
lens at 155mm; 1/250 sec at f5; ISO 200.

Sergey Gorshkov (Russia)
www.gorshkov-photo.com
www.instagram.com/sergey_gorshkov_
photographer
Agent: www.naturepl.com
14 Nikon D300S + 600mm f4 lens; 1/1250
sec at f5; ISO 800; Gitzo tripod + Wimberley
head.
82 Nikon D3 + 600mm lens; 1/640 sec at
f4.5; ISO 200.

Danny Green (UK)
www.dannygreenphotography.com
58 Canon EOS-1D Mark II + 500mm f4 lens;
1/100 at f5.6; ISO 400; tripod.

Andrey Gudkov (Russia)
www.wildanimalsphoto.com
90 Canon EOS-1D X + 100–400mm
f4.5–5.6 lens at 100mm; 1/2000 sec at
f7.1; ISO 800.

Jen Guyton (Germany/USA)
www.jenguyton.com
Agent: www.naturepl.com
36 Canon EOS 7D + Sigma 10–20mm
f4–5.6 lens at 10mm; 1/100 sec at f22; ISO
400; Venus Laowa flash; Manfrotto tripod.

David Hall (USA)
www.seaphotos.com
56 Nikonos RS + 50mm lens; 1/125 sec at
f11; Fujichrome Velvia; two strobes.

Charlie Hamilton James (UK)
www.charliehamiltonjames.com
Agent: www.natgeocreative.com
88 Canon EOS-1D Mark IV + 800mm lens;
1/1600 sec at f5.6; ISO 1000.

Tim Laman (USA)
www.timlaman.com
Agents: www.natgeocreative.com;
www.naturepl.com
26 Canon EOS-1D Mark IV + 600mm f4
lens; 1/180 sec at f5.6; ISO 1600; hide.

Frans Lanting (USA)
www.lanting.com
1, 30 Nikon FE2 + 300mm f2.8 lens;
Kodachrome 64.

David Lloyd (New Zealand/UK)
www.davidlloyd.net
62 Nikon D800E + 400mm f2.8 lens;
1/500 sec at f13 (-0.3 e/v); ISO 1000.

Michel Loup (France)
www.michelloup.com
8 Nikonos V + 15mm f2.8 lens;
1/125 sec at f11; Fujichrome Provia 400F.

Larry Lynch (USA)
www.lynchphotos.com
106 Nikon D2X + 80–400mm f4.5–5.6 lens;
8 sec at f8; ISO 200; SB-800 flash; Gitzo
3125 tripod; Manfrotto 468RC2 ballhead.

Jarmo Manninen (Finland)
www.jarmomanninen.net
38 Canon EOS-1D Mark III + Canon 300mm f2.8 lens + 2x extender; 1/250 sec at f5.6; ISO 800.

András Mészáros (Hungary)
www.meszarosandras.com
104 Canon EOS 5D + EF 50mm f1.8 lens reversed + 2 sets of extension tubes + EF 1.4x extender; 1/200 sec at f9; ISO 200; Gitzo 143 tripod + Manfrotto 469 ballhead; Canon 420EX flash; beanbag.

Fabien Michenet (France)
www.fabienmichenet.photoshelter.com
98 Nikon D800 + 105mm f2.8 lens; 1/320 sec at f16; ISO 200; Nauticam housing; two Inon Z-240 strobes.

Helmut Moik (Austria)
www.natureasart.at
18 Nikon F5 + 300mm f2.8 lens; 1/30 sec at f5.6; Fujichrome Sensia 100; tripod.

Vincent Munier (France)
www.vincentmunier.com
www.kobalann.com
48 Nikon D200 + 300mm f2.8 lens; 1/4000 sec at f4.5; ISO 200; tripod.

Alexander Mustard (UK)
Agent: www.naturepl.com
www.amustard.com
92 Nikon D100 + Nikon 105mm f2.8 lens; 1/45 sec at f13; ISO 200; Subal housing; Subtronic strobes.

Piotr Naskrecki (USA)
www.insectphotography.com
www.thesmallermajority.com
116 Canon EOS-1D Mark II + Canon MP-E 65mm macro lens; 1/160 sec at f16; ISO 400; Canon MT-24EX + two Canon 580EX flashes + small diffusion box.

Paul Nicklen (Canada)
www.paulnicklen.com
www.sealegacy.org
Agent: www.natgeocreative.com
20 Canon EOS-1Ds Mark III + 16–35mm f2.8 lens; 1/50 sec at f2.8; ISO 800.

Klaus Nigge (Germany)
www.nigge-photo.de
50 Nikon D2X + Sigma 300–800mm f5.6 lens; 1/20 sec at f7.1; ISO 250.

Pete Oxford (UK)
www.peteoxford.com
52 Nikon D1X + 105mm f2.8 Nikon lens; 1/50 sec at f18; flash; tripod.

Thomas P Peschak (Germany/South Africa)
www.thomaspeschak.com
Agent: www.natgeocreative.com
42 Nikon D3 + 14–24mm lens; 1/200 sec at f22; ISO 200; Nikon SB800 flash.

Isak Pretorius (South Africa)
www.theafricanphotographer.com
64 Canon EOS-1D X Mark II + 600mm f4 lens; 1/400 sec at f4; ISO 1600.

Steve Race (UK)
www.steverace.com
2 Canon EOS-1D Mark III + 500mm f4 lens; 1/800 sec at f6.3 (+0.7 e/v); ISO 400.

Espen Rekdal (Norway)
www.espenrekdal.no
40 Nikon F50 + 50mm lens; 1/125 sec at f22; Fujichrome Velvia; Ikelite housing; two Ikelite ss50 strobes.

Cyril Ruoso (France)
www.cyrilruoso.com
10 Canon EOS-1Ds Mark III + 400mm f2.8 lens; 1/200 sec at f2.8; ISO 400; tripod.

Steffen Sailer (Germany)
www.sailer-images.com
32 Canon EOS-1D Mark II + 17–40mm lens; 1/60 sec at f22; ISO 400; tripod.

Carl R Sams II (USA)
www.strangerinthewoods.com/carl-sams-photography
84 Nikon F4 + 300mm lens; 1/250 sec at f2.8; Fujichrome 100 rated at 200.

Wendy Shattil and Bob Rozinski (USA)
www.dancingpelican.com
76 Canon T90 + 800mm lens; 1/250 sec at f6.7; Fujichrome Velvia 50.
108 Canon F1 + 600mm lens; Kodachrome 64.

Robert and Virginia Small (USA)
www.eyesinthewild.com
44 Canon EOS-1 + 600mm lens; Fujichrome Velvia rated at 100; tripod.

Mac Stone (USA)
www.macstonephoto.com
54 Canon EOS 50D + 10–22mm lens; 1/8 sec at f22; ISO 100; Manfrotto Magic Arm + Super Clamp; Canon intervalometer.

Urmas Tartes (Estonia)
www.urmastartes.ee
16 Canon EOS 5D Mark II + MP-E65 f2.5 1–5x lens; 1/200 sec at f14; ISO 400; Speedlite 580EX II flash + home-made soft box.

Stefano Unterthiner (Italy)
www.stefanounterthiner.com
112 Nikon D2X + Nikon 12–24mm lens + graduated neutral-density filter; 1/250 sec at f10; ISO 125; flash.

Marsel van Oosten (The Netherlands)
www.squiver.com
124 Nikon D810 + Tamron 24–70mm f2.8 lens at 24mm; 1/320 sec at f8; ISO 1600; Nikon SB-910 flash.

Jan Vermeer (The Netherlands)
www.janvermeer.nl
12 Nikon D300 + 500mm lens; 1/800 sec at f7.1; ISO 400.

Steve Winter (USA)
www.stevewinterphoto.com
Agent: www.natgeocreative.com
60 Canon EOS XTi + 16–35mm f2.8 lens; 1/160 sec at f11; ISO 200; camera box; x3 Nikon SB-26 flashes; Trailmaster 1550-PS remote trigger.
80 Canon EOS Rebel XT + EF-S 10–22mm f3.5–4.5 lens at 14mm; 1/180 sec at f16; ISO 100; waterproof camera box; x3 Nikon flashes; Trailmaster 1550-PS monitor.

Konrad Wothe (Germany)
www.konrad-wothe.de
6 Canon EOS-1 + 600mm lens; 1/15 sec at f4; Kodachrome 200; car mount.

Tony Wu (USA)
www.tony-wu.com
Agent: www.naturepl.com
94 Canon 5D Mark II + 17–40mm f4 lens; 1/200 sec at f7.1; ISO 200; Zillion housing; Pro One optical dome port.
96 Nikon D800 + Sigma 15mm f2.8 lens; 1/200 sec at f11; ISO 200; Nauticam housing; Pro One dome port; two Nikon SB-910 flashes + custom Zillion housings.

INDEX

A FIREFLY BOOK

Published by Firefly Books Ltd. 2019

First printing

Library of Congress Control Number: 2018963259

A CIP record for this title is available from Library
and Archives Canada

ISBN 978-0-2281-0183-3

Published in the United States by
Firefly Books (U.S.) Inc.
P.O. Box 1338, Ellicott Station
Buffalo, New York 14205

Published in Canada by
Firefly Books Ltd.
50 Staples Avenue, Unit 1
Richmond Hill, Ontario L4B 0A7

First published by The Natural History Museum
Cromwell Road, London SW7 5BD

Author and editor: Rosamund Kidman Cox
Designer: Bobby Birchall, Bobby&Co Design
Image grading: Stephen Johnson
www.copyrightimage.com
Colour reproduction: Saxon Digital Services

Printed in China by Toppan Leefung Printing Limited